Basic
Landscape
TECHNIQUES

Basic Landscape
TECHNIQUES

edited by
GREG ALBERT
and
RACHEL WOLF

NORTH LIGHT BOOKS

Cincinnati, Ohio

Basic Landscape Techniques. Copyright © 1993 by North Light Books. Printed and bound in Hong Kong. All rights reserved. No part of this book may be reproduced in any form or by any electronic or mechanical means including information storage and retrieval systems without permission in writing from the publisher, except by a reviewer, who may quote brief passages in a review. Published by North Light Books, an imprint of F&W Publications, Inc., 1507 Dana Avenue, Cincinnati, Ohio 45207. 1-800-289-0963. First edition.

97 96 95 94 93 5 4 3 2 1

Library of Congress Cataloging in Publication Data

Basic landscape techniques / edited by Greg Albert and Rachel Wolf.
 p. cm.
 Includes index.
 ISBN 0-89134-464-0
 1. Landscape in art. 2. Art—Technique. I. Albert, Greg. II. Wolf, Rachel.
N8213.B37 1993
751.4—dc20 92-30062
 CIP

Designed by Sandy Conopeotis

The following artwork originally appeared in previously published North Light Books. (The initial page numbers given refer to pages in the original work; page numbers in parentheses refer to pages in this book.)

Clark, Roberta Carter. *How to Paint Living Portraits*, pages 107, 110, 112-114 (pages 53-57).

Dawson, Doug. *Capturing Light and Color With Pastel*, pages 4-5, 88-95, 112-116, 119-125 (pages 4-5, 75-81, 99-103, 113-117).

Goetz, Mary Anna. *Painting Landscapes in Oils*, pages 30-31, 46-49, 64-69, 137, 139 (pages viii, 14-19, 96-97, 108-111).

Katchen, Carole. *Creative Paintings With Pastel*, pages 44, 80-81, 86-87, 94-95, 105-106, 108-111 (pages ii, 26-31, 86-87, 92-95).
 page 81 (page 86) by Robert Frank
 pages 86-87 (pages 92-93) by Barbara Geldermann Hails
 pages 80, 94-95 (pages 87, 94-95) by Simie Maryles
 pages 44, 108-111 (pages ii, 26-31) by Elsie Dinsmore Popkin

Nofer, Frank. *How to Make Watercolor Work for You*, pages 7, 9-11, 67, 102, 105, 114-117 (pages v, 32-35, 42-45, 112).

Pike, Joyce. *Oil Painting: A Direct Approach*, pages 29, 112-115 (pages 50-51, 59).

Roycraft, Roland. *Fill Your Watercolors With Light and Color*, pages 76-77, 90-91, 96-97 (pages 38-41).

Sovek, Charles. *Oil Painting: Develop Your Natural Ability*, pages 5, 61, 67, 110-111, 113-115 (pages 3, 5, 36-37, 60-61, 89-91, 98).

Stine, Al. *Watercolor: Painting Smart*, pages 6-7, 12-13, 16-18, 20, 22-23, 56-57, 65-69, 127, 132-134 (pages 2, 6-11, 20-25, 62-73, 104-107).

Webb, Frank. *Webb on Watercolor*, pages 80-83 (pages 82-85).

ACKNOWLEDGMENTS

The people who deserve special thanks, and without whom this book would not have been possible, are the artists whose work appears in this book. They are:

Roberta Carter Clark	Frank Nofer
Doug Dawson	Joyce Pike
Robert Frank	Elsie Dinsmore Popkin
Mary Anna Goetz	Roland Roycraft
Barbara Geldermann Hails	Charles Sovek
Carol Katchen	Al Stine
Simie Maryles	Frank Webb

TABLE
of
CONTENTS

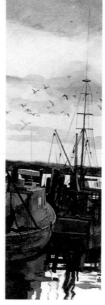

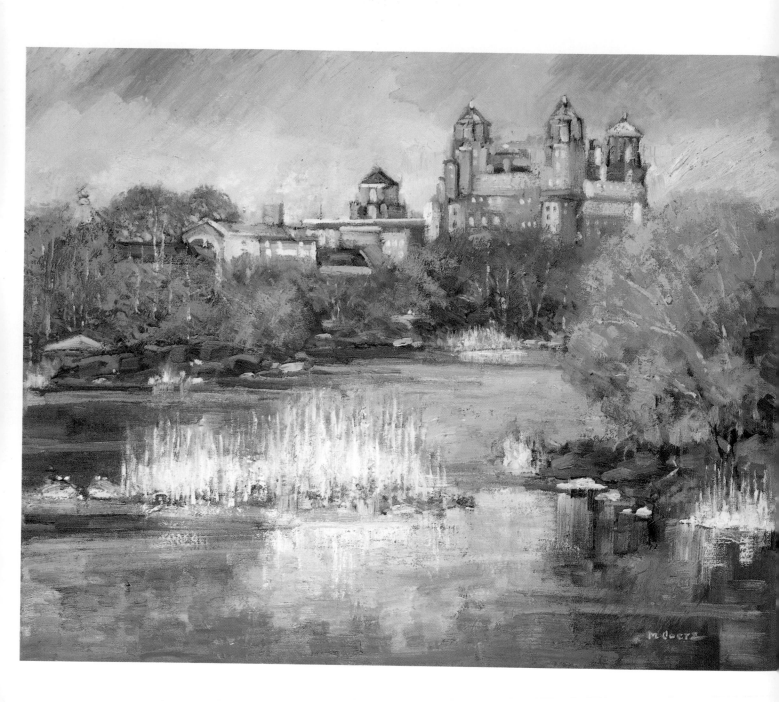

INTRODUCTION

Landscape is one of the most exciting and challenging subjects. It is also one of the most satisfying for both the artist and the viewer. Landscape painting may seem daunting—after all, there's so much there to paint. But with practice and careful observation, you'll soon see satisfying results.

This book offers instruction and encouragement to all painters, regardless of the medium the painter prefers. Oil, watercolor, pastel—they're all here.

We have assembled this book from some of the best teaching on landscape painting that's available—everything the beginner needs to get off to a smooth start. In the first chapters you will find useful information on materials and color, painting on location, using photos as reference material, and techniques of landscape composition. The latter part of the book teaches the basic principles that will help you tackle some of the most intriguing features of landscape painting. You'll learn to create depth and explore ways to paint light, water and snow. The only additional ingredients you will need are practice and the knowledge that interest and effort overcome any lack of that elusive quality we call "talent."

Chapter One
BASIC MATERIALS
Everything You'll Need to Get Started

Most painters are fascinated by all the equipment that we use for painting. For most of us, this fascination began with our introduction to painting when we were mystified and confused by all the materials needed. We were impressed with the array of brushes, paints and other paraphernalia that more experienced painters had accumulated. Most of us have since become gadgeteers and collectors, with a lifelong habit of picking up anything that might be useful.

Despite all the gizmos that most artists keep in their paint boxes or on their studio tables, we rarely use more than one or two of them on any one painting. Instead, we usually stick to the basics. Although it is fun to collect odds and ends for special tricks and effects, there is no magic in them. They won't do your painting for you.

Good painting begins with knowing what the basic tools and equipment will do. Eventually you'll find it easy to choose a special tool for a particular texture or effect. In this section, we'll take a look at the essential tools needed for oil painting, watercolor and pastel.

In addition to getting the right materials and learning to use them, it is important to set aside a permanent place in your home to work, preferably one where you can retreat to paint undisturbed. Many artists have started their careers on the kitchen table, but having a space dedicated to your art can be a real asset. You'll find that you can focus your energies best in familiar surroundings with all your equipment close by. You'll associate your studio with creative activity, and it will be easier to get into the mood to paint there. It also helps to know where everything is so you can reach for a tool or brush without thinking about it.

Having the right light to paint by is also important. The ideal lighting is overhead, color-balanced fluorescent lighting. You don't want to be painting in your own shadow. Ordinary fluorescent bulbs are too cool and incandescent lights too warm to make good color choices. It can be a real shock to see a painting done in cool fluorescent light under warm incandescent light.

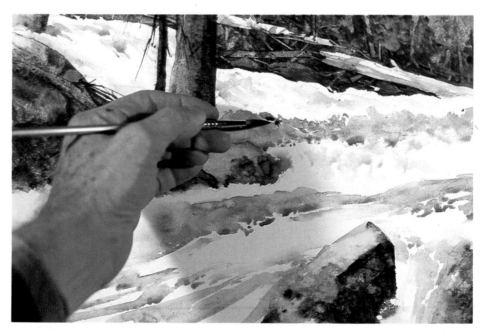

A good round watercolor brush allows you to paint broad strokes with the side of the brush, as well as some finer detail with the point.

Kitchen Interior With Flowers
24" × 30"
Charles Sovek
oil on canvas
collection of Lori Cutler-Goodrich,
Rowayton, Connecticut

Many artists have started their careers on the kitchen table, but having a space dedicated specifically to your art can be a real asset.

Materials for Oil Painting

The following list includes all the materials needed for basic painting in oil. As your knowledge increases, so will your stock of materials and your sensitivity to different colors and brushes.

First, let's look at a list of suggested colors. They all don't have to be purchased right away. You can have a perfectly serviceable palette from just the starred colors. Purchase the rest gradually, as desired.

Oil Colors

cobalt violet
alizarin crimson *
cadmium red light *
cadmium yellow medium *
cadmium yellow pale
Naples yellow
burnt sienna *
permanent green light
Thalo or viridian green *
cerulean blue *
ultramarine blue *
black
Thalo red rose
brown madder
cadmium orange
cadmium yellow light *
yellow ochre
raw sienna
burnt umber
sap green *
Thalo blue *
cobalt blue
Payne's gray
white (large tube) *

Painting Knife

Be sure to get a painting knife with an inverted handle. It's much easier to manipulate than a flat palette knife.

Brushes

You need at least a dozen flat, bright or filbert bristles in sizes 1 through 12 (two of each of the even sizes nos. 2, 4, 6, 8, 10 and 12 are good ones to start with). A no. 5, 6 or 7 square sable softens edges and does detail work. Buy a small no. 2 or 3 square or round rigger for small accents and highlights unobtainable with any of the other brushes.

Brush Washer

A brush washer is a mandatory item for keeping your brushes clean between strokes. Silicoil makes a jar with a coiled wire at the bottom especially made for cleaning oil painting brushes. You may choose to buy the jar and not the can of cleaning fluid that's sold with it. Turpentine or paint thinner will do the job just as well and at a fraction of the cost.

You could also make your own brush washer by using an empty peanut butter or jelly jar with a coiled-up wire coat hanger at the bottom. Whether you buy or make a brush washer, your oil painting equipment isn't complete without one.

After a day's painting, clean your brushes one last time by first swishing them out in the cleaning jar and then thoroughly wiping them clean with your fingers using a mild soap and warm water. Make sure there isn't any excess paint left in the brush.

Brush Dauber

For a brush dauber, use a tuna or cat food can stuffed with a couple of paper towels to daub off a drippy brush before mixing a fresh batch of paint.

Painting Surfaces

Stretched or unstretched primed cotton or linen canvas, canvas board or 1/8-inch Masonite (covered with two coats of gesso, one horizontal and one vertical) makes a suitable surface for oil paint. Sizes can range from panels as small as 9-by-12 inches all the way up to 20-by-24 inches or even larger. The best all-around sizes for the exercises in this book are from 11-by-14 inches to 16-by-20 inches.

Palette

Plate glass with a piece of white paper or cardboard beneath is ideal to use for a palette in the studio but impractical for travel and location painting because of its weight and fragility. White Plexiglas, on the other hand, is suitable for both purposes. Ideally, you should have both glass and Plexiglas, with Plexiglas cut to fit your painting box for field work and the larger plate-glass palette on your taboret for studio work. White or gray paper tear-off palettes are fine in a pinch but tend to deteriorate after repeated brushing.

If you do choose a paper palette, use two of them, a larger one for holding the colors squeezed from the paint tubes and a second, smaller one, placed on top of the first and reserved for the actual mixing of paint. When the smaller mixing palette is covered, simply tear off the filled page and you instantly have a fresh surface to work on without the inconvenience of disturbing the colors on the larger palette. Tan or brown natural wood palettes may be distracting to work on because the

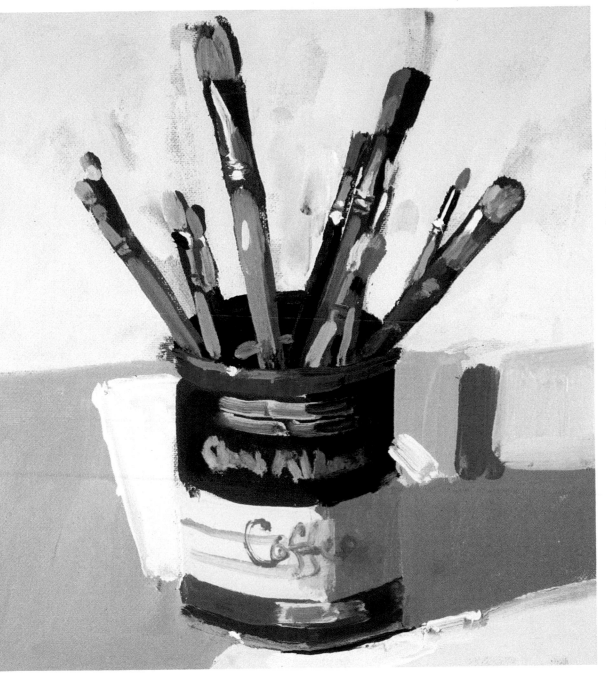

Brush Can
12" × 12"
Charles Sovek
oil on canvas
collection of
Martha Rodgers,
Atlanta, Georgia

warm color and deep tone hamper judgment in mixing colors and values objectively (especially when working on a white canvas).

Razor Blade Scraper

The hardware store variety scraper made for scraping old paint from a building or window is particularly useful for quickly scraping wet or dry paint from your palette and providing a clean space for new mixtures.

Medium

Use undiluted turpentine for laying in a painting with thin washes or toning a canvas. Some useful mediums are Res-N-Gel (Weber), Win-Gel (Winsor & Newton) and Zec (Grumbacher); while not as flexible as a mixture of stand oil (or linseed oil) and turpentine, they do give the paint a juicy quality that some painters find attractive. You'll also need some portable medium cups that can be stored in your painting box along with your paints and brushes.

Turpentine, Paint Thinner

Turpentine is used for washing out brushes. Wood-distilled gum turpentine is less of a health hazard than petroleum-based paint thinner or mineral spirits.

Paper Towels or Rags

Rags are okay but tend to get saturated quickly, so you may want to use a high-quality paper towel.

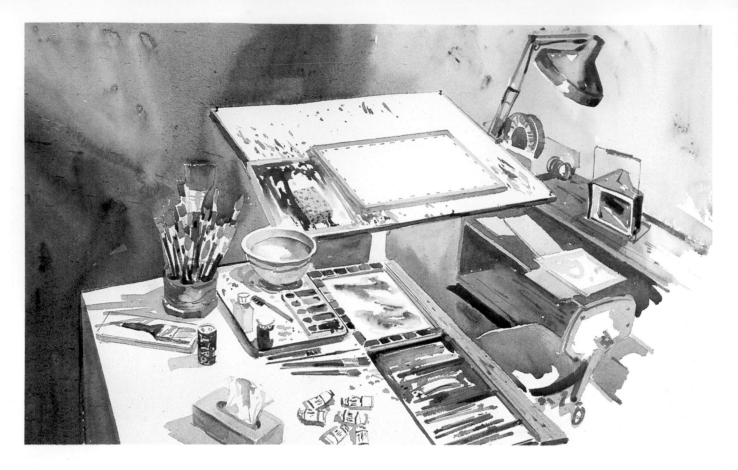

This is a watercolor of artist Al Stine's studio setup.

Materials for Watercolor Painting

Let's start with a look at the watercolor tools we just can't do without: brushes, colors, paper, a palette, boards on which to stretch the paper, water containers, sponges, tissue, a pocket knife, HB pencils, erasers, a spray bottle and a sketchbook. We'll also discuss some of the nonessential but handy items needed for special purposes.

Brushes

There are many excellent brushes on the market, and a few that are not so good. Buy smart when purchasing brushes. That almost always means buying the best brushes you can afford.

Red sable-hair brushes are the most expensive, but they are also undoubtedly the best. With proper care, they will last for a very, very long time and will prove to be a wise investment. If you can't afford red sable, ox-hair brushes are a good second choice. There are also some new synthetic brushes out which are much less expensive but have gotten good reviews from watercolor painters. They should be springy and hold a good point. Synthetic fiber brushes with some natural fibers, such as the Winsor Newton series 101 Sceptre, are very good choices, especially the rounds.

The following selection of brushes is recommended for the beginner. There are enough brushes to get the job done but not so many that choosing the right one becomes troublesome when painting.

Use a 2-inch Robert Simmons Skyflow for wetting the paper, for painting backgrounds and for painting skies. This brush does have synthetic fibers, but still holds a good charge of

water. For a versatile selection, use three red-sable flats—a 1½-inch, a 1-inch and a ¾-inch—and four red-sable rounds—nos. 12, 8, 6 and 4. The larger the number, the larger the brush. Use the largest brush you can when painting; small brushes invite fussiness. Keep an oil painter's ½-inch bristle brush for applying heavy pigment into wet areas and a small, ⅛-inch oil bristle brush for scrubbing and lifting out small areas of a painting for rocks and stones. Use a no. 4 rigger—a long, thin brush—to paint fine lines such as the rigging of ships, lacy tree branches and grasses.

Brushes are a major investment, so it pays to take good care of them. First, never use your sable or ox-hair brushes for acrylics, which tend to dry near the ferrule (the metal sleeve that holds the hairs on the wooden handle) and eventually ruin the springiness of the hairs. If you do use acrylics, use synthetic brushes.

Second, you should clean your watercolor brushes thoroughly after every painting session. Make it a habit to rinse them in clear water after each use. Many artists also use a mild soap to remove any residue that may linger in the bristles. Always make sure you rinse out all the soap.

Third, store the brushes in a way that protects the fibers, such as vertically in a brush holder, as shown in the illustration on page 5. Transport them taped to a piece of stiff cardboard. If you do store your brushes for a long time, put a few moth crystals in their container. Moths love sable hair. Of course, the best way to combat this problem is to use your watercolor brushes every day!

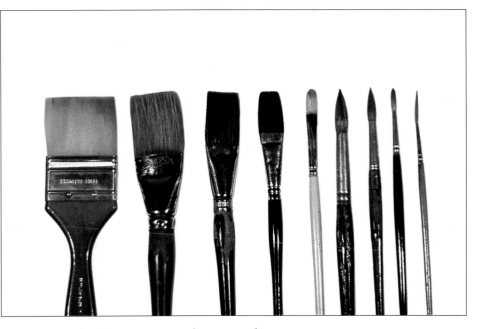

A selection of brushes appropriate for watercolors.

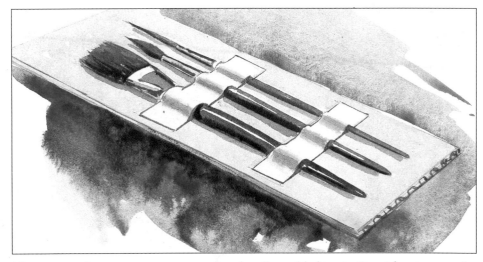

This is a good way to transport your brushes. For added protection, place a second piece of cardboard on top and tape the pieces together.

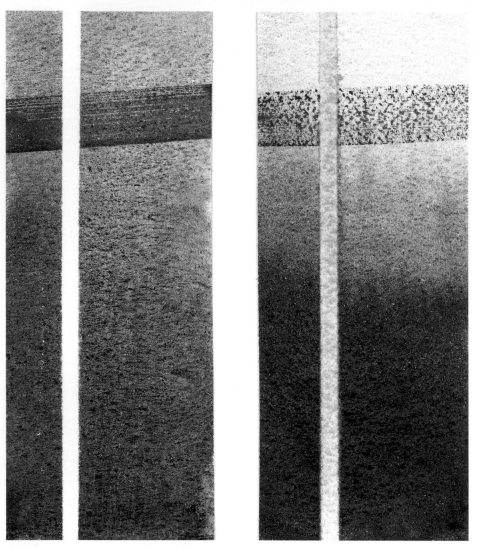

These are gradated washes of French ultramarine blue on 140-pound Arches cold-press paper (right) and 112-pound Crescent Rough Watercolor board (left). A strip of dry brush shows the difference in texture. Color was also lifted with a sponge after masking out an area with tape. As you can see, the color lifts off the board more easily than the paper, giving you much cleaner whites.

Paper and Board

Watercolor paper comes in various weights and textures. When we speak of the *weight* of the paper, we mean how much 500 sheets of a particular paper weighs. For example, if 500 sheets of a paper weigh 140 pounds, it's called 140-pound paper.

The less a paper weighs, the more it wrinkles and buckles when it is wet. Paper lighter than 140-pound will need to be stretched. The heavier papers can be held down on the drawing board with large clips, and the very heaviest can be used unmounted.

The standard size watercolor sheet is 22-by-30 inches. You can purchase full sheets from your local art supply store or by mail order. A half-sheet (22-by-15 inches) is the size most commonly used by watercolorists. Paper can also be purchased in blocks. Watercolor blocks are pads of paper glued together on all four edges; you work on the top sheet, then slide a knife around the edges to separate it from the block when it is dry. Blocks come in sizes from 7-by-10 inches to 18-by-24 inches, and in a variety of weights and textures.

Watercolor papers come in several different textures. Very smooth paper is called hot-press because it is made by passing the paper between large, hot rollers. Cold-press paper has a more textured surface because it has not been subjected to heat in its manufacture. Rough paper has a distinctly textured surface.

Paper texture and technique are closely related. Some techniques will work on rough or cold-press paper but not on hot-press, and vice versa. For instance, dry-brush techniques are not very effective on the smooth surface of hot-press paper because the dry brush is supposed to deposit color on the ridges of the paper's surface. On the other hand, the smooth surface of the hot-press paper allows for easier lifts and wipe outs.

Palettes

You can use anything from a dinner plate to a butcher tray for your palette, but there are a number of excellent plastic palettes made just for watercolor. A John Pike palette, a plastic palette with a tight-fitting lid and twenty wells for colors, works well. The wells surround a large central mixing area and are separated from it by a small dam that keeps the mixtures from creeping into the colors. The top can also be used for mixing colors. This palette is airtight, so at the end of the painting session, you can place a small damp sponge in the center of the tray and replace the lid. The colors will stay moist and ready for use for several days.

Notice the list of colors includes a warm and a cool of each primary (for example, both Winsor blue—cool, tending toward green—and French ultramarine blue—warm, tending toward purple). This will allow you to create color temperature contrast even when using one basic primary. Having a cool and a warm version of each primary helps you mix complements without getting mud.

Also keep an assortment of secondary colors (colors composed of two primary colors), including cadmium orange, an intense orange difficult to mix using other colors, and cobalt violet, a hard color to get by mixing.

It's a good idea to arrange your colors with the cool colors on one side and the warm on the other. Put your colors in the same place every time so that you won't have to hunt for them. You need to be thinking about what colors you want to mix not where to find your colors.

Be generous when putting colors on your palette—you need plenty of pigment to paint a watercolor, and digging and scrubbing for color while painting will only disrupt your thinking process.

A basic palette of colors, as shown below, contains (left to right):
- *olive green*
- *Payne's gray*
- *cobalt blue*
- *Winsor blue*
- *Hooker's green dark*
- *French ultramarine blue*
- *cerulean blue*
- *Winsor green*
- *alizarin crimson*
- *cadmium red*
- *cadmium orange*
- *cadmium yellow pale*
- *lemon yellow*
- *cobalt violet*
- *burnt sienna*
- *burnt umber*
- *Van Dyke brown*
- *raw umber*
- *raw sienna*
- *brown madder alizarin*

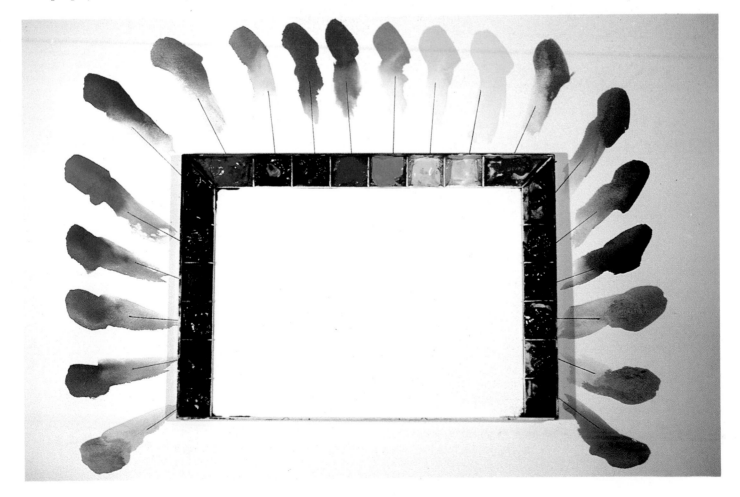

Special Tools for Watercolor

Here is a quick look at some of the special tools you can use to achieve various effects and textures. These are just a few examples of the way to use them.

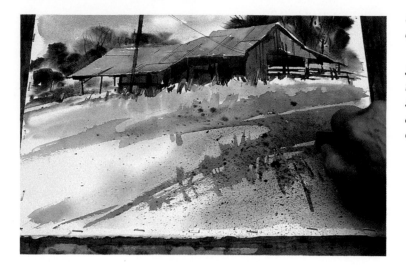

Untitled, 9" × 14", Al Stine, watercolor collection of Mr. & Mrs. Robert W. Klatt

Spattering with a toothbrush is an effective method of texturing. To get larger spatters, load a round brush with color and rap it sharply on the handle of another brush or across your fingers.

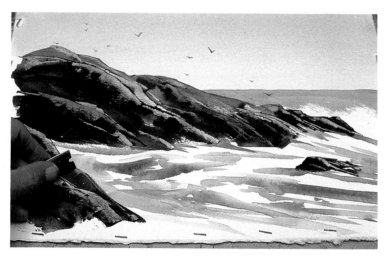

A razor blade or a credit card is a good tool to use to indicate rocks. While the paint is still moist, scratch out the lighter forms of the rocks.

Applying salt to the colors while they are still wet on the paper creates interesting textures. This method is especially suitable for winter scenes. Table salt was used in this painting.

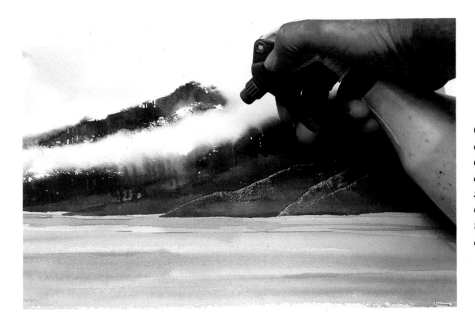

One of the best methods for painting clouds and fog banks is to first wet most of the area with a brush and clear water and then spray some of the edges of the same area with a spray bottle. When the color is put down, you will get some very interesting edges that can only be produced using a spray bottle.

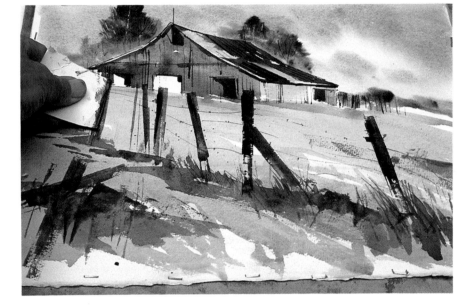

After all the basic washes had dried, the artist stamped the indications of boards on the barn and the larger posts in the foreground using various sizes of mat board scraps. Stamping with mat board scraps is done by mixing a puddle of color on the palette, picking it up with the edge of the board, and applying it to the painting.

Untitled, 9″ × 14″, Al Stine, watercolor collection of Dr. & Mrs. Clifton Straughn

One way to indicate brush or leaves on trees is to pick up the color on a sponge—a natural cosmetic sponge is best—and apply it to the painting. (Be judicious in using this technique, because the painting can get dry and scratchy-looking if you overdo it.) Stamping with a sponge is also a good way to indicate sagebrush and grasses.

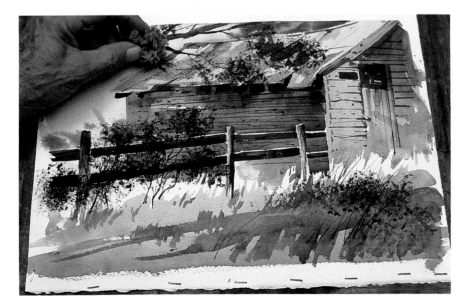

Materials for Pastel Painting

There are many different kinds and qualities of pastel sticks available today. Soft pastels give rich, paint-like textures. There are several good brands, and, generally, you get what you pay for. Rather than buying a set of pastels, you may choose to put together your own set, including soft pastels from many different brands. Start with dark, middle and light values of about a dozen colors.

Easel

It's better to work on an easel than a table. On an easel the pastel dust falls away from the painting's surface. With a table it just lies there getting in the way.

Drawing Board

Try a piece of ⅛-inch Masonite.

Masking Tape or Clips

Use a clip or piece of tape across each corner to hold the paper on the board.

Bristle Brush

This is handy for brushing pastel away if it needs to be removed. It works equally well on paper or sanded board.

Fine Sandpaper

This may be used to remove pastel on paper and at the same time rough up the paper so it is receptive to pastel again.

Selection of Soft Pastels

Keep a dark, middle and light value of each of the colors you choose. If you

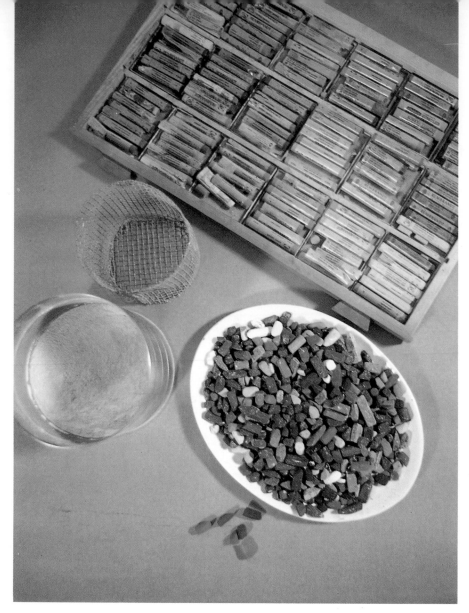

This shows pastels stored in drawers; pastels set out on a porcelain plate; a coffee can, wire basket and rice flour for transporting pastels; and a small group separated out to use.

start out with a small set, expand it so that you have a dark, middle and light value of each color in the set.

When you buy a new stick of color, cut a slit in the paper and break off a piece of pastel about a half-inch long. Keep the pieces of pastel on a porcelain plate next to your easel. Store the sticks in a drawer until you need more of a particular color. Save the papers. They have codes on them identifying the hue and value of each stick.

Store and transport your pastels in rice flour. The pieces of pastel are placed in a basket made out of heavy window screen. This basket in turn is placed inside a coffee can and rice flour is poured over the pieces. The rice flour cushions them, preventing breakage during travel. To use the pastels, just sift the rice flour out, dump the sticks back onto your palette, and you're ready to work.

Methods of Application

Pastel can be applied with a tip for linear strokes, with the side for broad, flat strokes, or as powder, sprinkled on or applied with the touch of a finger. You can't mix pastel colors the way you can mix a liquid medium. Pastels can only be mixed by painting one layer over another. Pastel can be blended by working one stick of color into another, or by rubbing with a finger, stump or tissue. They can be moved around by painting into them with water or turpentine.

Removing Pastel

If the pastel gets too heavy, whisk some away with a bristle brush. Use this method on paper or board. Sometimes the pores of the paper become so filled with pastel that slick, shiny spots develop. What has happened is that the tooth of the paper has been crushed by repeated applications of pastel. The bristle brush won't help. These spots can be revitalized and the pastel removed by gently sanding them with a piece of light sandpaper. But don't use sandpaper on a sanded board. The sandpaper will remove its sandy surface.

Fixative

Fixative causes the light values to darken and the colors underneath to bleed through to the surface. Therefore, it is not wise to seal a finished painting with a fixative. If you are going to use fixative, use it only to seal coats of pastel you intend to cover with an additional coat. Instead of spraying a finished painting with a fixative, strike

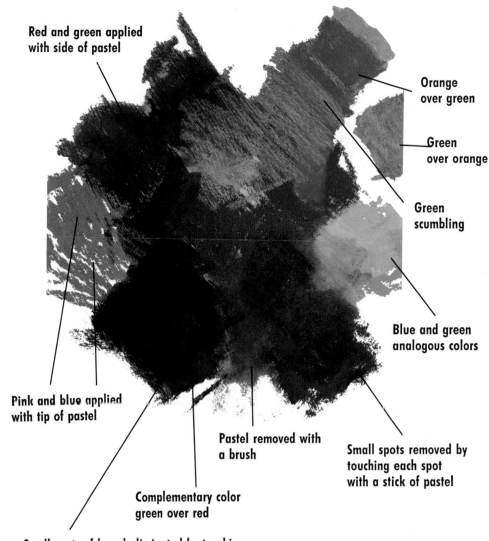

Red and green applied with side of pastel

Orange over green

Green over orange

Green scumbling

Blue and green analogous colors

Pink and blue applied with tip of pastel

Pastel removed with a brush

Small spots removed by touching each spot with a stick of pastel

Complementary color green over red

Small spots of board eliminated by touching with the little finger

the board several times on the back. These blows knock off any pastel that is loose enough to fall off later. If small open areas result, retouch these before framing.

Paper and Board

The pastel paintings in this book were done on Canson paper, etching paper or Masonite board. Of the Canson pa-

pers, the lighter brown or gray tones work well with pastels. Avoid the dark papers and brightly colored ones. The front side of the Canson has a screen-like texture that some artists find objectionable, but the back side is smoother. While any etching paper will work, try the texture of German etching. Tone the etching papers with accidental washes of acrylic or casein.

Chapter Two
ON LOCATION
Painting in the Great Outdoors

When working outside the studio, it is important to consider problems that might arise because of the particular spot where you have decided to set up. The following are some things to consider before heading out to paint:

• Are there restrooms nearby? If not, don't plan to work too long!

• Are food and beverages available nearby? If not, bring your own.

• Is the spot where you want to paint possibly unsafe? If so, bring someone along with you.

• Will insects be a problem? If so, arrive prepared with insect repellent and wear long pants and a long-sleeved shirt.

• Will you be standing in the hot sun? If so, bring suntan lotion or work under a tree or shelter.

• Don't set your easel up where you will be asking for trouble—in the middle of the sidewalk or a pathway in a park. Leave plenty of room to get around you.

What to Wear

Warm Weather
On a hot day, dark clothing is too warm. However, a white shirt will reflect up into the painting, causing a glare. Khaki-colored clothing is perfect for painting in warm weather.

Cold Weather
Everyone's tolerance for cold is different, but usually at thirty-two degrees or above you can work at least an hour and a half if you are properly dressed.

Hands and feet are the biggest problems. It is impossible to paint with bulky gloves that have no flexibility. Thin wool gloves work quite well. Buy several cheap pairs. Once the gloves are covered with paint, they aren't as flexible as they originally were and it is best to start with a new pair.

Buy the best and warmest boots. Be sure they are lined and water resistant. Wear two or three pairs of wool socks and set up your easel in a dry area. Al-

ways wear a warm hat. An old down-filled ski jacket is perfect for painting in winter. Wear warm clothing underneath, too. If it warms up, you can take your jacket off and still work comfortably.

General Tips About Dress
• Always wear a sun visor or cap with a bill to block reflected light and to ward off glare.

• Never wear sunglasses when painting. They distort the color of the subject.

• Wear old clothes or a smock. There's a good chance your clothes will be soiled.

• Even in winter, wear clothing that is as lightweight as possible. You will be carrying enough weight around transporting your equipment.

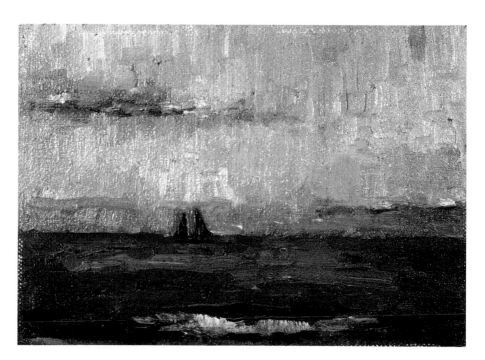

Ketch on the Delaware
8″ × 10″
Mary Anna Goetz
oil on canvas
collection of Andrew Newman

The artist painted this painting on a windy afternoon, avoiding problems by working on a small canvas. The clamp on her easel was enough to hold the painting steady.

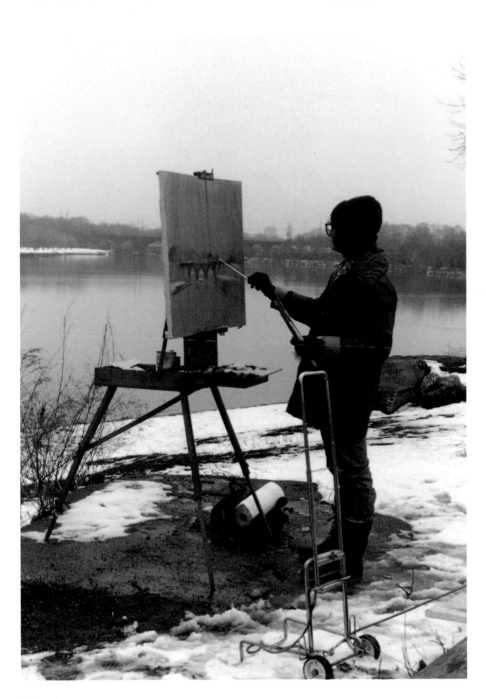

Artist Mary Anna Goetz is shown painting on the Schuylkill River in Philadelphia. The temperature was around thirty-eight degrees. She was dressed in a warm hat, an old down jacket over a flannel shirt and sweater, good boots and thin wool gloves and was comfortable enough to work for several hours.

Weather

Wind

A gusty day can be an exciting time to paint, but it is almost always maddening, especially if the sky is full of clouds. On a windy, cloudy day the clouds will be moving swiftly across the sky, causing the sun to peek in and out constantly. These dramatic light changes are difficult to contend with and the clouds are difficult to paint because they are changing all the time. You'll also need to anchor your canvas or board as well as any lighter-weight equipment so it won't blow away.

Rain

If you really want to work from nature on a cloudy day when there's the chance of rain, set up under a sheltered area. A picnic shelter can save a painting outing on a rainy day. Shelters are often located in nice parks, surrounded by beautifully landscaped country.

Oil Painting on Location

When oil painting on location, double-check to make sure you've brought everything you need. The following are essentials:

• Paint box and sketch easel or easel box containing: colors, brushes, turpentine, linseed oil, palette, oil cup for medium, container and rags for cleaning brushes, and palette knife for scraping your palette

• Backpack or satchel containing: rags for cleaning brushes, plastic bag for used paint rags, umbrella and extra clothes if needed

• Viewfinder

• Extra canvas or panels

Transporting Wet Canvases

To get your wet paintings home without smearing them or ruining your clothes, try plastic spacers (available at most art supply stores). These are ideal for carrying two paintings together. They look like thick pushpins, with pins on the top and bottom. Mount the canvases together with the spacers, wet sides facing each other, and put them in a plastic bag.

Most good French easel boxes are equipped with a prong that slides out enabling you to carry a canvas on your box itself. Mount it so that the wet side is facing in.

Step 1: Toning the Canvas. The canvas was toned with a mixture of equal parts burnt umber and burnt sienna. To counteract the cool morning light and green foliage, this was a warm mixture.

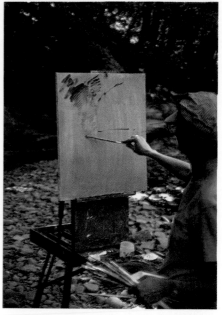

Step 2: Working Out the Masses. To emphasize the feeling of light emerging through the tunnel of foliage, the dark trees were massed in first.

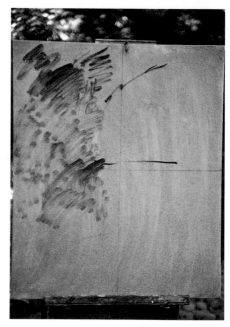

Step 3: Initial Lay-In. To keep the dark mass of trees and reflection in the creek from cutting the painting in half, trees were placed to the left of center and the tree line indicated on the right.

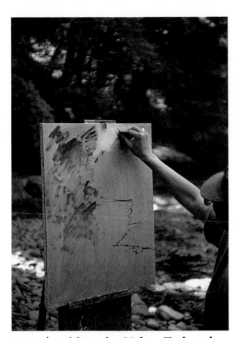

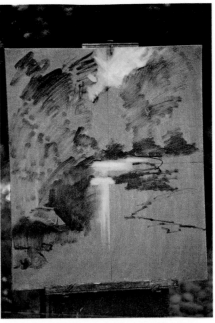

Step 5: Developing the Composition. Abstract patterns were used to define the focal point and key elements. Detailed shadow areas are massed in and lightest lights wiped out.

Step 4: Adding the Lights. To key the sky as one of the lightest notes in the composition, most of the grisaille was wiped out in this area. The focal point will be the reflection of the sky in the water.

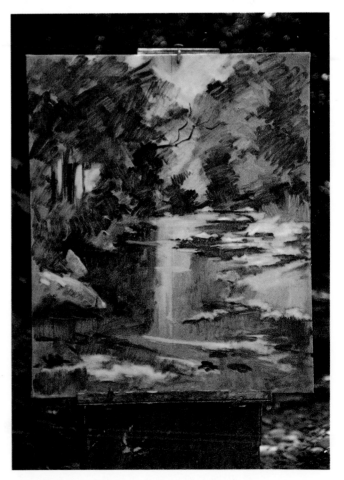

Step 6: The Finished Grisaille. With the grisaille painting finished, it's time to begin applying color. The technique is still loose and abstract, establishing good description, focal point and design.

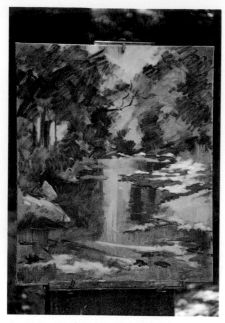

Step 7: Applying Color. When applying color, concentrate on the focal point. Keep in mind what drew you to this subject in the first place. At this stage, concentrate on big masses.

Step 8: Designing the Focal Point. Dark foliage is what helped create the tunnel look in this composition. This was massed in early. The light side of the trees was important because this is reflected in the water.

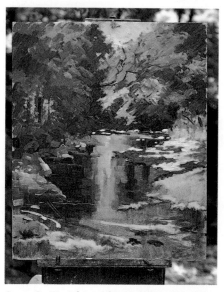

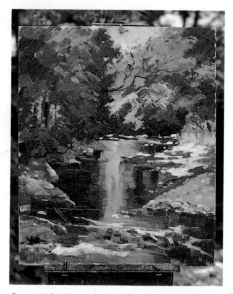

Step 9: Finishing the Foliage. Working from the focal point out, be sure the original idea is not lost in a lot of detail. Define key elements before moving on. Avoid the rapids until the final stage of the initial application of color.

Step 10: Designing the Rapids. The rapids draw the viewer into the composition. Too much detail would draw the eye away from the focal point. The light is clear and bright, the shadows dark and cool.

Basic Landscape Techniques

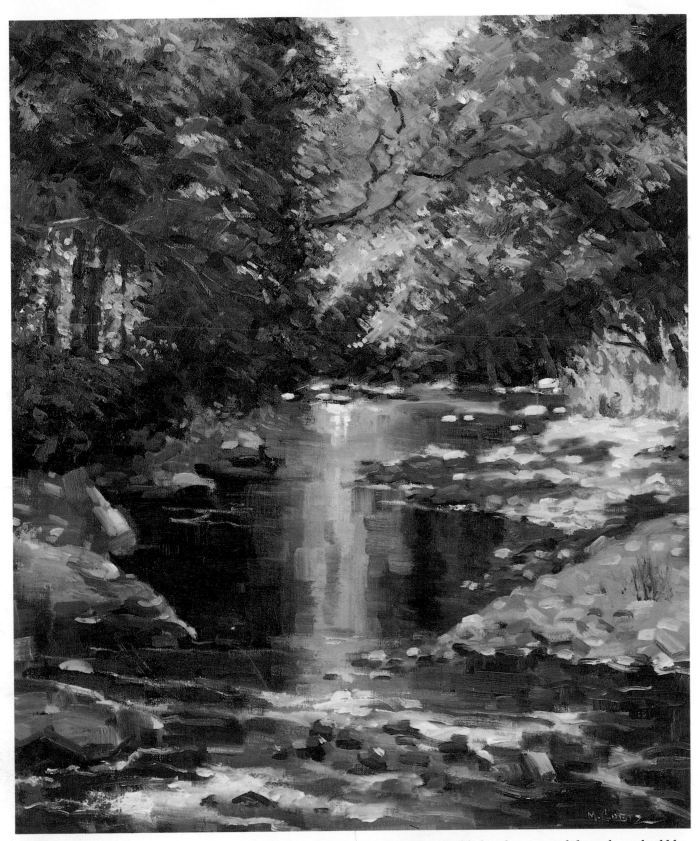

Calicoon Creek in Summer
24" × 20", Mary Anna Goetz
oil on canvas
collection of Dr. Robert B. Page

To finish the painting, more texture was added in the trees and the rocks and pebbles on the bank were refined. When painting foliage it is necessary to build up texture to make the trees and bushes more convincing.

The rocks on the left, protruding into the water, and the rapids looked finished, but the sunlit pebbles needed more attention. Modeling created a smoother transition from shadow to light and indicated more contour in the mound of pebbles in half-light (closer to the foreground). A little pure white pigment was added to the reflection.

Watercolor Painting on Location

Most watercolorists sketch and paint outdoors, even if they do their best work in the studio. Working on the spot encourages you to "think on your feet," to simplify your subject and work economically, with just enough colors and brushes to do the job. Paintings done on the spot may be less refined than those done in the studio, but they are usually more spontaneous and energetic.

When you paint outdoors, you don't have the time to worry about tricks. You're so occupied with observing your subject that you forget all about good or bad technique and focus on getting it down on paper. It also encourages you to work boldly because you don't have the time to mull over every possible choice.

Because the light outdoors changes constantly, try to establish the lights and darks right off the bat. Do the thumbnail sketches while thinking about where your darks will go, then transfer your drawing onto the watercolor paper.

Occasionally you will be unable to finish a painting on location due to lack of time or to changing light or weather conditions. Don't despair! Simply take your painting and finish it indoors.

Here is artist Al Stine painting on location. The equipment is light and portable.

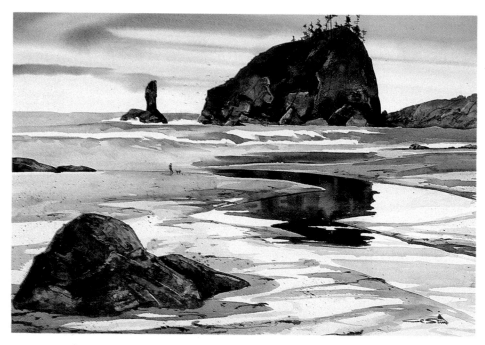

Second Beach, La Push
18" × 26", Al Stine, watercolor

An isolated beach near La Push Indian Village in Washington. Some places offer unlimited opportunities for good subjects to paint, and this is one of them.

Basic Landscape Techniques

Typical materials for painting water-colors on location include the following:

• French easel and paint box with a palette and brushes—a 3-inch Robert Simmons Skyflow for wetting the paper and doing large washes, a 1-inch flat, a ¾-inch flat, nos. 6 and 8 rounds and a no. 4 rigger

• Backpack or satchel with colors, sketching pens, pencils, an old tooth-brush, salt, 8½-by-11 inch sketchbook, water, rags and a box of tissues

• A half-sheet of stretched water-color paper or a 140-pound Arches cold-pressed watercolor block (16-by-20 inches)

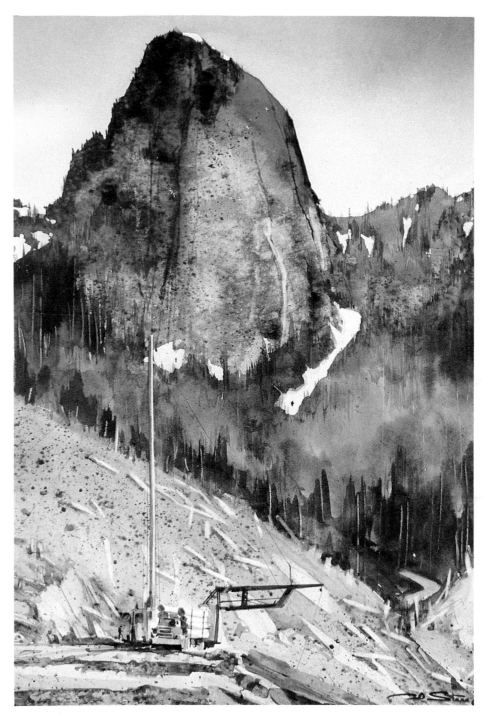

High Country Logging
19" × 13", Al Stine, watercolor
collection of Mr. and Mrs. Earl Graham

A logging operation in Campbell River on Vancouver Island.

Demonstration

There is an Indian village called La Push on the Olympic Peninsula near Seattle. At low tide there are glorious tide pools and streamlets up and down the three-mile beach, reflecting the huge monoliths guarding the shore.

This painting is an excellent example of getting the most from a limited palette of four colors: French ultramarine blue, Hooker's green dark, burnt umber and raw umber. This selection gives a wide range of colors and grays while helping to preserve color harmony throughout the picture. Using a limited palette also helps to simplify things when you're painting on location.

Step 1: After doing several thumbnails, artist Al Stine made this larger value sketch. Ruling off this sketch in squares made it easy to transfer the drawing to paper.

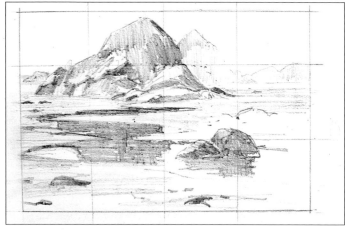

Step 2: Lightly rule off the paper in squares and transfer the drawing to the paper.

Step 3: Wet the sky area with clear water, going around the monolith but including the background rock structures, down to the horizon line. Working from the top, use French ultramarine blue with a little added burnt umber, adding a little Hooker's green dark at the horizon line.

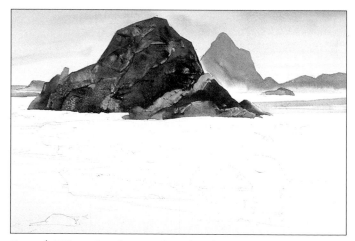

Step 4: When the sky area has dried, paint the distant rock formations. To paint the monolith, mix three separate puddles of color—one each of French ultramarine blue, Hooker's green dark and burnt umber. Keep the pigment fairly heavy. Use a razor blade to scrape into the wet colors to help create the planes and formation of the rock masses. A little salt offers more texture. The Hooker's green dark stains the paper, and where the other colors are scraped off you get a lovely, soft effect from the underlying green.

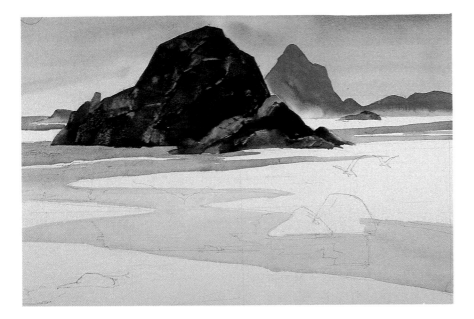

Step 5: The water of the tide pools and streamlets was painted with juicy, wet, horizontal strokes using the same colors that were used for the sky.

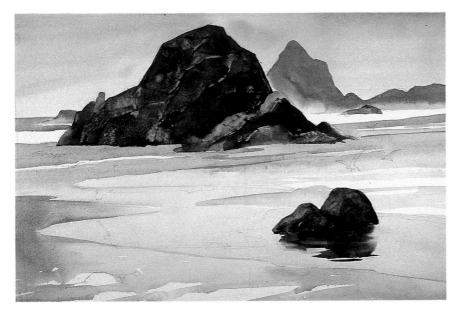

Step 6: Using raw umber, French ultramarine blue and a little burnt umber, the water line, where the sand would be wet, was worked. Where the sand would be drier, warmer and lighter, values of the same colors were used. The same colors were used for the monolith, but warmed with burnt umber. Graying down the same colors, the reflections of the rocks were painted, softening the edges a bit with clear water.

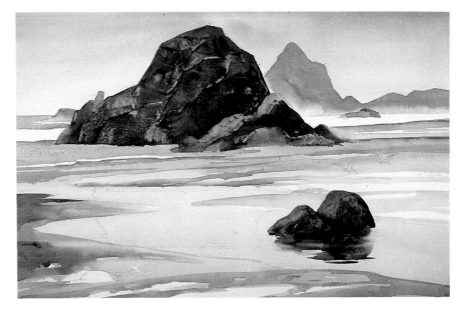

Step 7: Returning to the sand, some of the edges were darkened, especially near the water where they would be wet, darker and cooler. Notice the variety of hard, soft and rough edges.

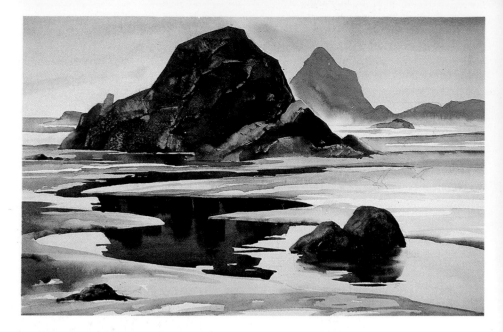

Step 8: When everything had dried, the reflections of the large monolith were painted into the tide pool. While still damp, some darker areas were added for even more of a reflective quality. The small rock in the left foreground adds balance. Softening a few of its edges into the sand makes it look as though it were buried there. The edges of the tide pool are delineated with darker values.

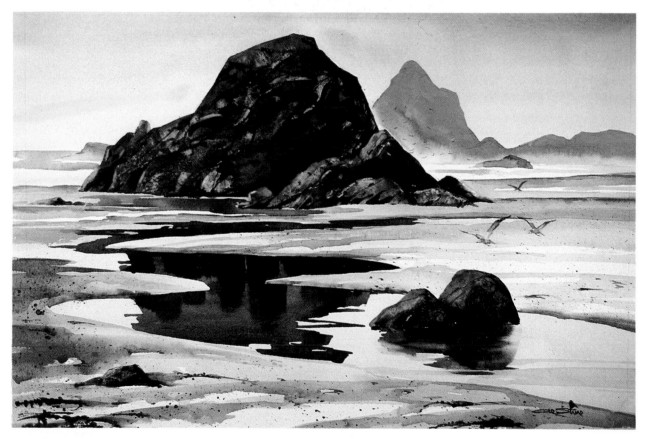

Low Tide at La Push
13" × 19", Al Stine, watercolor
collection of Mr. and Mrs. C. Richard Hallengren

Texture was added to the beach by spattering with a toothbrush and tapping a brush full of color for larger spatters. Then the seagulls and the seaweed lying on the beach were painted. Going back to the monolith, detail was added, mainly with negative painting, but also by lifting out areas by scrubbing with a small bristle brush and blotting with a tissue.

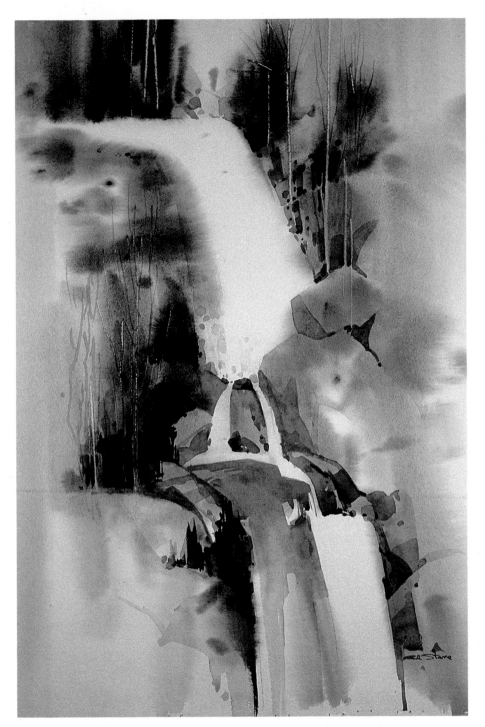

Outdoor subjects are sometimes very complex and fast moving. Painting the "feel" of the landscape with abstract forms can be a good alternative sometimes. These falls in North Carolina are said to be the highest east of the Mississippi. First, the entire surface of the paper was wet, and then experimental shapes were brushed in with cool colors. The trees and rocks were brushed on in warmer colors while the paper was still wet. As the paper dried a little more, the trees were scraped out with the brush handle. When the painting had dried completely, the detail was added by negative painting.

Whitewater Falls in Abstract
20" × 11", Al Stine, watercolor
collection of Mr. and Mrs. James Patterson

Pastel Painting on Location

Whether you like to paint indoors or outdoors, from life or from studies, pastel can work well for you. Its versatility is one of its greatest attractions.

Some artists like to paint with pastels in the studio where boxes of pastels and a supply of paper are readily available. Others decide to make watercolor studies on location and expand those into pastel paintings in the studio.

Artist Elsie Dinsmore Popkin regularly takes her pastels outdoors. She has developed an organized system—shown here—for virtually transporting her studio out into the landscapes that she paints.

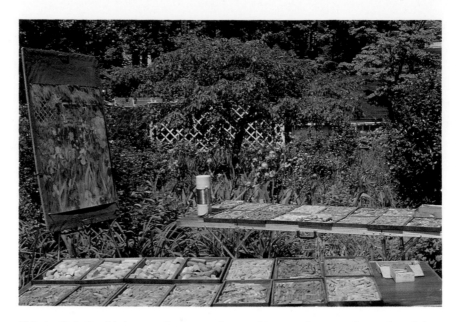

This is Elsie Popkin's complete setup for working outdoors in the midst of the lush gardens and woods she loves to paint. For artists who are interested in trying the adventure of painting outdoors, on the next page she passes along her tips for making it as easy as possible.

"For drawing boards I use Homosote, which is light, sturdy and easy to put pushpins into. I use the extra-long (½-inch) pushpins because they hold in the wind. I cover the smoother side with heavy kraft paper to keep the texture from coming through. Then with an awl or drill I make two holes about two inches apart, on each end of the board about a half-inch from the end. I run clothesline through from end to end, looping it around through the holes so there are two lines running down the back of the board. These can be used to sling the drawing board over my shoulder as I schlep my equipment to the site."

"Once there, I can secure the board on the easel by hooking an elastic luggage strap around the back leg of the easel and through the little end loops."

"If there is even a hint of wind, I weight the easel down by putting the legs through bricks with holes in their centers."

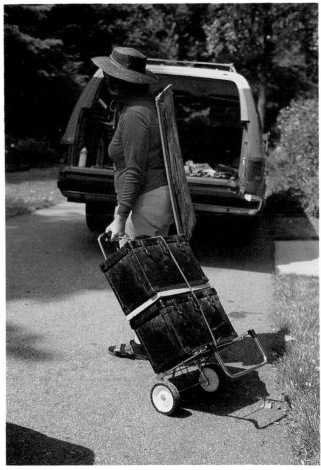

"I load the cases onto a large wheeled luggage cart if I have any distance to go with them from car to site."

"I keep my pastels in jeweler's sample cases, ordered from Fibre Built division of Ikelheimer/Ernst, 601 W. 21st St., New York. It's better to get two shorter ones than one tall one, as they are heavy when filled. I line the bottoms with tin foam to cushion them. I use a piece of foam insulation with a hole cut out for the handle, placed on the bottom case so the cases can be stacked."

Demonstration

Searching out compositions in nature can be a greater challenge than arranging models and props in the studio. The sunlight and shadows in the living landscape create colors much more vivid and subtle than those in the studio. And you'll never have to stop for a model to rest.

For working outdoors, the materials, tools and painting technique must be portable.

On this and the next three pages, you'll see examples of the subjects and techniques pastel artist Elsie Dinsmore Popkin employs when painting on location.

This photo of the subject was taken on the first day of painting. By the time Popkin finished, the spring foliage was much more lush.

Step 1: She begins with a charcoal sketch on sturdy Rives BFK paper indicating placement of path, trees and bushes. The greenish tone is an acrylic-marbledust wash applied to the paper earlier.

Step 2: With her hardest pastels she blocks in the large shapes that organize the composition. Notice that from the beginning she uses a variety of strokes, but all larger than those that will finish the piece.

Step 3: She works over the entire surface, painting most densely in the background where the darkest values are. She looks for patterns in the shapes, the parallel lines of trees, the diagonal rows of pink flowers in the lower left.

Step 4: She now develops the colors and textures of the flowers. The pattern of sunlight begins to show. She leaves the strokes unblended, finding that blending blurs and dulls the colors.

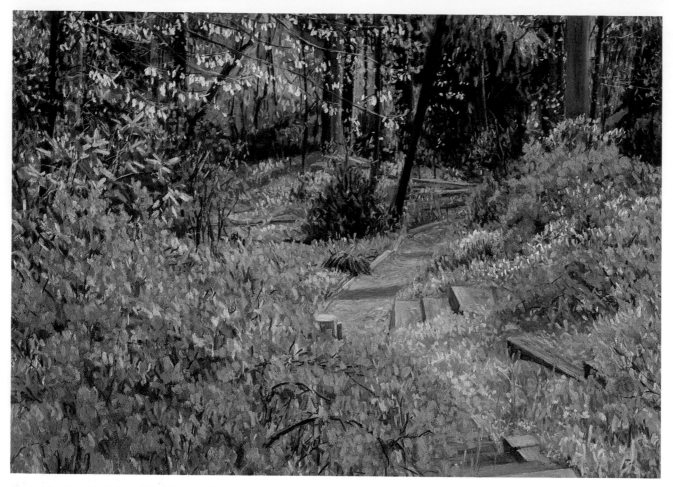

Pat's Garden With Carolina Silverbells
22" × 30", Elsie Dinsmore Popkin, pastel

Step 5: Once the darks have been dug out, she can "embroider the surface," keeping the can of fixative spray on hand. Sometimes, for a more "painterly" stroke, Popkin works into the wet fixative. The painting is finished with equal attention to detail and brilliance throughout.

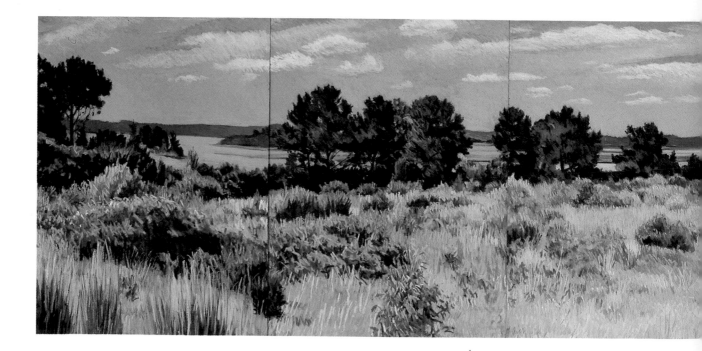

Basic Landscape Techniques

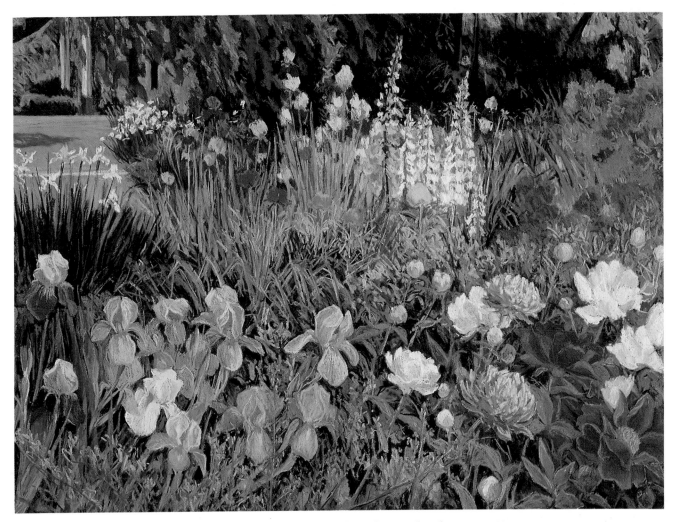

Dr. Spur's May Garden—Irises and Peonies
38″ × 50″, Elsie Dinsmore Popkin, pastel

Working outdoors has its disadvantages. You can never count on the weather cooperating for long, so there may not be time to do extensive studies. Take photographs of the site as you begin, in case of a freeze or heavy rain.

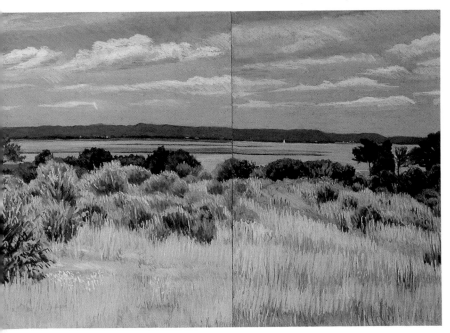

Bogue Inlet Panorama
30″ × 110″ (five panels 30″ × 22″ each)
Elsie Dinsmore Popkin, pastel

At the North Carolina beach in June, Popkin painted one panel per day, working from 10 A.M. to 6 P.M. When she got back to her studio, she pinned all five panels on the wall and matched up the clouds, water and islands.

Chapter Three
PHOTOSKETCHING
Painting From Photographs

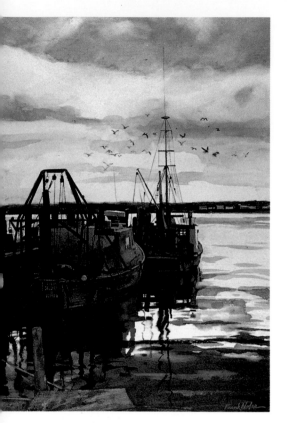

Harbor Sunset
20¼" × 15¾", Frank Nofer, watercolor
courtesy of Newman Galleries

The duration of this dramatic evening lighting condition was about half an hour and there was no guarantee that the boats would stay put. Photosketching was the only logical approach.

Photography now plays an important and controversial role in painting. Regarding the use of photography to help develop realistic watercolors: painters fall into four categories: 1.) those who paint only on the spot and, in some cases, frown on those who don't; 2.) those who use a camera but are reluctant to admit it; 3.) those who intelligently employ *photosketching assistance* and make no bones about it; 4.) those who rely entirely on photographs and strive to duplicate them in paint.

It's no misdemeanor to use a camera, but almost a felony to let the camera use you. The intention of a representational watercolor is to have the viewer react to the subject matter as you did. Especially in outdoor painting, if you haven't spent considerable time "in the field," your paintings will tend to have stage-setting overtones. Once you have *on-the-spot tenure,* you can evaluate the subject matter photo-

sketching can offer. For instance, painting watercolors on the spot in frigid weather is next to impossible.

The camera *must* be regarded as a sketching tool used to bring an abundance of visual information into your studio. With a camera you can record details and forms that are too elusive to sketch in a real-life situation (just try to sneak up on a deer, for instance). When you are working on the scene, you must quickly and accurately sketch in the elements of your composition and compensate for changing light patterns.

It is also difficult to rearrange elements on site to improve the design of your painting. The ideal vantage point is not always accommodating and you cannot expect humans, wildlife or moving automobiles to pose for you. But don't ever use someone else's photographs as the basis of a painting, and don't attempt to duplicate photos with your brush.

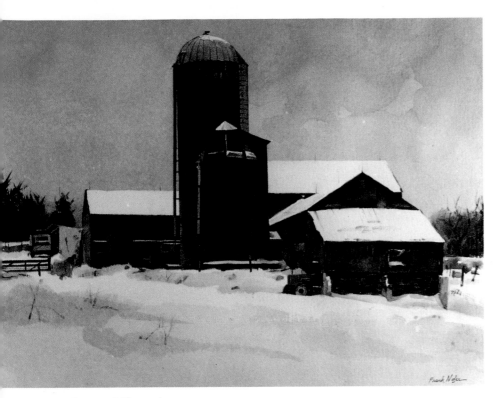

February Silhouette
17" × 23", Frank Nofer, watercolor
collection of Mr. and Mrs. Ernest Hermann

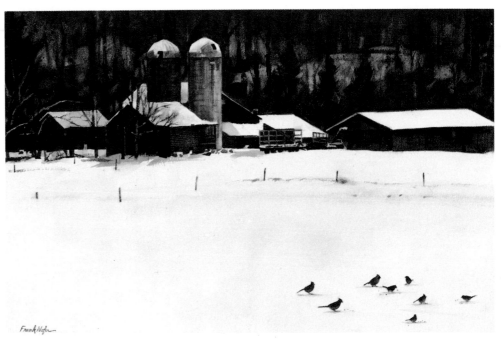

Slim Pickin's
12" × 18½", Frank Nofer, watercolor
private collection

In the case of this winter watercolor, a good vantage point was not possible. Hence, a quick, on-foot photosketching session provided an adequate studio reference.

Exploiting Your Camera

Nature offers an abundance of paintable beauty—sunlit forests, snow-blanketed fields, bubbling brooks, bursting surf, to name a few. And human creations—towering skyscrapers, bridges, farmhouses and silos, traffic-clogged highways, contemporary shopping malls—also present a wealth of visual themes for the representational painter. While challenging subject matter is bountiful, already-existing, ideal compositions are in short supply.

Frequently, the problem is the appropriate vantage point—finding the position from which the scene offers the best compositional potential. To improve a so-so composition, you may need to change your viewpoint by only a few feet. Other times, a move of hundreds of yards may be necessary. But often the perfect point of view is dangerous, illegal or physically impossible for the painter with palette and easel. The photosketcher, however, can enjoy visitation rights that the encumbered painter cannot have.

The best way to use photosketching is to open up new possibilities in composition. For example, with a camera, you can stand in the middle of a stream bed and photosketch it—not exactly an easy feat with a set of watercolors. When exploring new vantage points, do so with your senses first. Make firsthand observations of the colors, sounds and your responses to your surroundings. Then photograph what intrigues you for reference.

Just where can photosketching take you? Here are only a few examples:

Roadside Vistas. The danger of attempting to paint from the edge of a major highway is obvious, but carefully pulling off the road for a minute or two of photosketching is safe. Observing the change of seasons from a highway that you frequently travel can spark paintings with a variety of color or a different mood.

Mid-Stream. With a pair of hip boots and a 35mm camera you can photosketch waterfalls, riffles and deep blue pools that heavy shoreline vegetation obliterated, both in winter and in summer.

A Different Level. Knee- or foot-level views can change the entire attitude of a picture. You can dramatize the foreground by lying on your stomach, as opposed to standing and concentrating on distant subjects.

Detail. Record intricacies of a flower from eight or nine inches away with a macro lens. Such closeness isn't such a safe painting distance if a bee has chosen your flower for pollinating.

Clarity From a Distance. A telephoto lens can close the gap between you and distant, unapproachable subject matter—a boat far out on a lake or a farm scene inaccessible because of a barrier fence.

Breaking With Tradition. With the help of a camera, you can paint familiar subjects in a nontraditional way. For example, try looking directly upward at closely grouped skyscrapers. If you're on good terms with your chiropractor, you can lean backward for hours and paint from that vantage point. But for most people, this is a good place to trade paint and easel for a camera. Another interesting vantage point is looking down over your subject.

Patterns and Elusive Subjects. Use your camera to capture patterns made by bridge structures, tree branches against the sky or an upward view of a construction crane. All are ripe sub-

The distant vista was great—the vantage point was wet.

Why not move in closer? The sign on the tree and a roaming Doberman pinscher said, "No!"

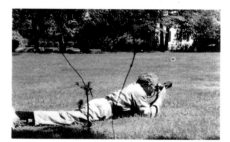

A skittish herd of deer in the next meadow suggested an unobtrusive low vantage point.

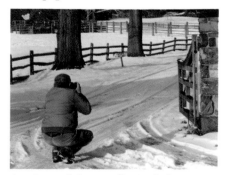

A private driveway limited close visitation rights. A telephoto lens solved the problem.

A cold, encumbered, but effective vantage point.

The center of this intersection provided the best view of the church, but photosketching time was only forty-five seconds between red lights.

jects for unusual vantage-point photosketching, as are elusive subjects such as small birds.

Don't Concoct. When choosing an unusual vantage point, select one that's believable. In the studio you can improve on it and make it more intriguing, but it must not look concocted. You're an artist, not an acrobat, and for your finished painting to reveal that you had to contort yourself to achieve a certain point of view doesn't enhance your work. The viewer who observes your painting stands in your shoes, and he wants that stance to be a comfortable one.

Absorb Yourself in Your Surroundings. Whenever you are photosketching, completely absorb yourself in identifying with your surroundings. Your personal interpretation as you choose your subject matter will give your work the creative spark. Don't just take random snapshots—always have a concept in mind when you push the

shutter release button. But don't confuse photosketching from unusual vantage points with special effects photography. What you're after here is using the camera as a sketching tool to enhance your paintings.

A Thorough Workout. In all photosketching endeavors, give your subject a good workout. Use a gray card, if necessary, for setting the light meter, bracket your exposures and shutter speeds, and experiment with depth of field (f-stops).

Don't forget a few shots of details pertinent to your subject. For instance, if you are photographing a forest scene, you may include a squirrel, an interesting leaf formation, or a tree with unusual bark texture. For a seascape, include seagulls and shells on the beach, and if you're creating a farm scene, don't forget livestock, chickens, a tractor or beat-up pitchfork. And always add photos of interesting people to your scrap file.

Here are five experimental variations of the same basic photo print. You can crop your photos, put in or take out foliage, cut them up, or splice two or three photographs together to come up with a pleasing composition.

Using Photos in the Studio

Eventually you will be able to develop your composition with the same freedom and spontaneity as when working directly from life. *Avoid rotely duplicating the composition of any of your sketches or photographs.* Instead, try to improvise as you paint, using the reference material more as a point of departure to elaborate on than a visual agenda to slavishly copy. Develop the painting just as if the subject were in front of you. If any of the material seems lacking, make a mental note to emphasize that aspect of your research next time you go out.

Photographs typical of the kind used when working in the studio.

Exercise. The aim of this exercise is to bridge the gap between location work and studio painting and develop a consistent approach. Whether painting from life, reference material or a combination of the two, your approach and style should be the same. Every painter finds his own way of using sketches, notes and photographs. Whatever devices you use to help you succeed are unimportant as long as the finished result is a statement of quality.

Basic Landscape Techniques

*Color sketch
painted on
location.*

*A page of carefully written impressions
of the subject's tonal and color make-
up can be used in conjunction with a
painted location sketch or photographs
or as your primary source of reference
material.*

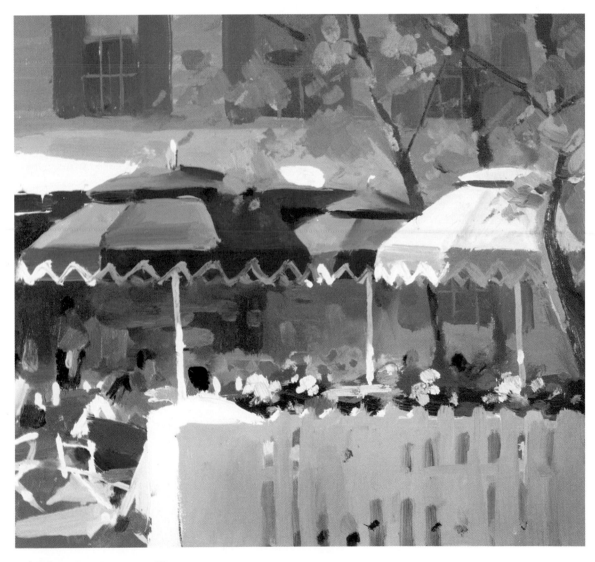

*Cafe Blase, Provincetown #2
12" × 12", Charles Sovek, oil on canvas, collection of James Watterson, Chagrin Falls, Ohio*

*Using photographs, color sketches and notes, as well as memory of the subject, the artist completed this
studio painting in a single twelve-hour session. The most difficult thing about doing studio paintings is
keeping the feeling of immediacy that is present when working on site. Try playing tapes of music that relate
to a particular subject.*

Composition Design From Photos

A word of caution: Don't try to fake subject matter, even though you can create atmosphere that didn't exist in the photographed scene. If you combine two or more sketches or photos (or combinations of sketches and photos) into a single picture, be sure they are all related in terms of subject, perspective, light source and natural habitation.

Once you've chosen your reference materials, make a series of thumbnails—small compositional sketches—to determine value patterns. Try various horizon lines, focal points, lighting effects and arrangements of elements until you find the combination that suits the situation best. Do several thumbnails of each subject; if you stop with just one, you might miss an even

In this scene, notice the interesting action line of the building against the sky.

The action line here has a lacy appearance; you can see this especially clearly in the thumbnail. But notice how the gaps between the trees have been simplified.

There's a good tonal pattern here, a good three-value (light, medium and dark) composition. But the foreground will need simplifying, which has been done in the thumbnail.

better idea. Each thumbnail should take only a few seconds to draw. Keep them small, 2-by-3 inches to eliminate detail. In fact, they can be almost abstract, since you want to concentrate primarily on getting the distribution of the values right. Once you've settled on their placement, you want them fixed clearly in your mind before you begin to paint. You may wish to do a thumbnail in color to establish the palette you'll use.

Enlarge the compositional thumbnail to fit the full size of the stretched watercolor paper. Pencil in precisely all the necessary details you want to include. You may have difficulty enlarging thumbnails accurately and retaining the correct shapes. Use a Pantograph or opaque projector, or try manual transfer methods using a grid or scaling on the diagonal.

The wildflowers in the foreground work well but the background needs development. In the thumbnail, the three values are more distinctly defined.

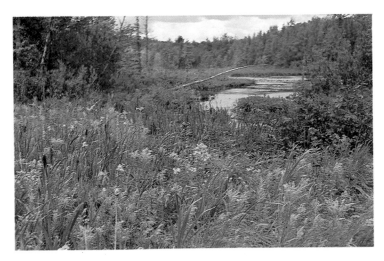

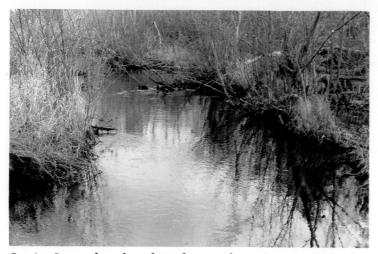

Coming In *was based on this reference photo. Compare it closely with the action line in the painting to see how this worked.*

Action Line for Coming In. *This composition was based on the upside-down action line you see here. The action line is the reflected silhouette of the sky and trees in the water.*

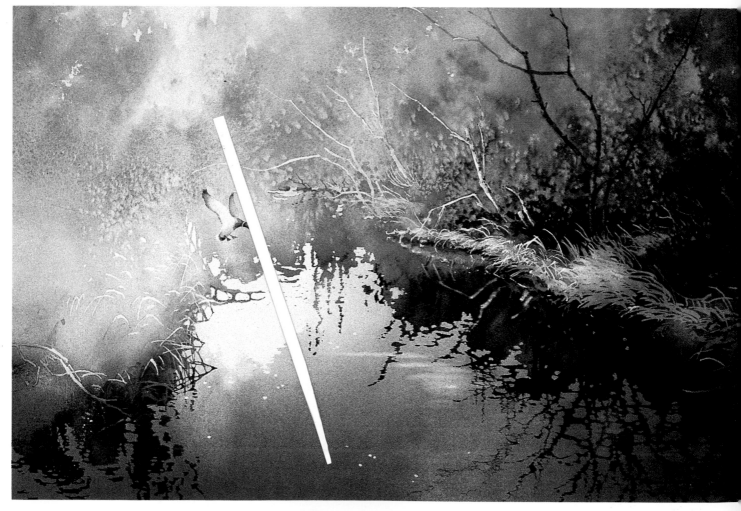

Coming In
21" × 14", Roland Roycraft, watercolor

Masking on the action line formed hard edges. The glow caused by the backlighting reduced the foliage to soft edges, offering a nice contrast and the illusion of depth behind the duck.

Basic Landscape Techniques

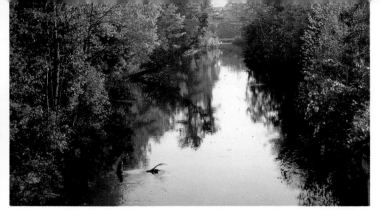

This is the reference photo for Butterfly on the Betsie.

The values and composition were in this thumbnail.

The thumbnail was followed with the initial masking.

 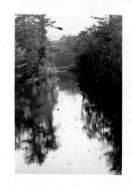

"BUTTERFLY ON THE BETSIE"

The reference photo was cropped with this mat to get a good composition.

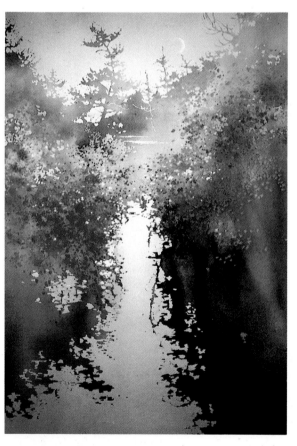

Butterfly on the Betsie
14" × 21", Roland Roycraft, watercolor

THE TRADITIONAL LANDSCAPE
Trees and Wide-Open Spaces

Composing a landscape painting is not a simple matter of choosing an attractive arrangement and copying it faithfully. In the first place, the world offers such a variety of subjects that finding just the right one can be a challenge. And the scene itself will change as you are painting it. The angle of the cloud formations and the weather affect the subject you are viewing. In addition, the number of colors and values that meet your eye in the outdoors can be staggering. To make the most of the time you spend painting, it's necessary to know something about the process of visual perception.

How the Eye Perceives

Simply put, the basic challenge of painting is to translate the three-dimensional world onto the two-dimensional surface of paper or canvas—to somehow capture the experience of human vision. The following tips on visual perception will provide you with creative options rather than compromises based on the limitations of your flat canvas or paper.

When viewing three-dimensional subject matter, the human eye has limited depth- and breadth-of-field perception. That is, it cannot keep the foreground, middle ground and background in focus at the same instant, nor can it include a wide expanse of subject matter.

Unlike a still camera, which can record extensive depth- and breadth-of-field on film, the human eye constantly scans, moving its focus from one area of interest to another, accumulating a series of mini-images which it then assembles into a complete picture. In fact, television and motion-picture producers accommodate the human eye's penchant for motion. The next time you "fix focus" on a TV screen, you might notice that the TV camera is doing the scanning for you—moving, shifting, panning and focusing on detail in the way your eyes normally do.

Bearing in mind the limited depth- and breadth-of-field capability of the human eye and its relentless propensity for scanning, consider the following five options in the initial stages of a painting.

1. Dismiss the idea of painting all areas of the picture in sharp focus. Instead, capture the phenomenon of human perception rather than that of a still camera.

2. Evaluate whether the foreground, middle ground or background presents the greatest visual interest. Then zero in on that area of the painting and subordinate the rest of the picture to it.

3. Scan the subject matter and try to lead the viewer through the painting by determining a well-designed pathway paced with visual stopping points.

4. Consider a combination of options two and three, above. First, choose an area for first-priority visual development. Then, through the introduction of limited detail, contrast or special color, accent other small areas of the painting. But it's most important that these additional areas of attention be well patterned and appropriately support the main statement of the work.

5. Occasionally, the arrangement of shapes and colors is so exciting that a two-dimensional translation of the subject matter is the best interpretive choice. The paintings of Picasso, Matisse and the later work of Milton Avery can hardly be called realistic, but their legacy of consummate surface composition should be recorded in every painter's genes. Even with a predominantly "flat" surface design you can control how the viewer scans your painting with the use of selective detail, color intensity, and size and arrangement of shapes.

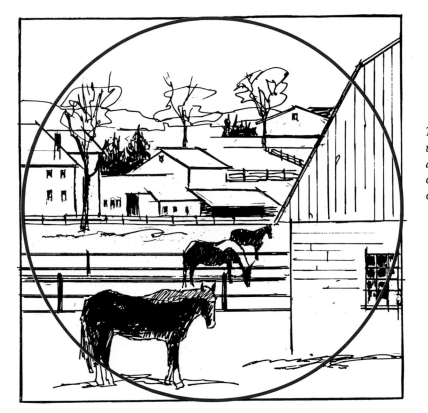

This rather rough pen-and-ink sketch of a landscape with horses illustrates the difference between camera and human vision. The red circle indicates how a camera takes in everything in one gulp without discrimination.

Unlike a camera, the human eye chooses a pathway of visual stopping points as it scans any given subject matter. It then quickly puts together the pieces and completes the puzzle. The red bullets suggest the visual route the eyes might take.

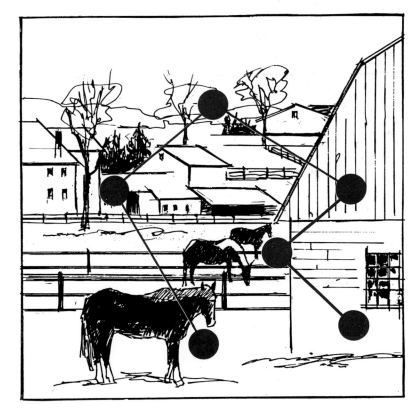

Should Detail Wag the Dog? The human eye scans and moves its focus from one area of interest to another, and it is only at those periods of focus that the eye concentrates on detail.

Detailing is a basic technique for creating stopping points, and thus leading the viewer along your chosen path. But a little detail goes a long way. A bit of wisdom many art instructors recite is, "When you paint a bunch of grapes, paint the form of the whole and then highlight three individual grapes. The eye will do the rest." Inviting the onlooker to participate in the comple-tion of your painting furthers his personal involvement and, in a sense, makes him a coauthor of the work.

The "Hair and Feather" School. However, another school of thought differs in opinion. Some artists pride themselves in detailing every square inch of their paintings. This "super realism" goes beyond how the eye actually sees, and requires exquisite balancing of all detail to avoid overkill. But if successfully executed, it proves fascinating to those who are enamored of meticulous craftsmanship.

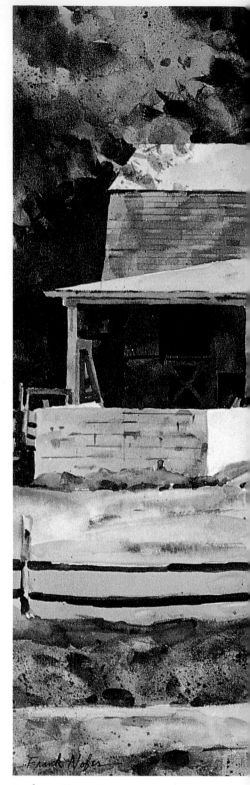

Andorra Horse Farm
21½" × 27½", Frank Nofer, watercolor
private collection

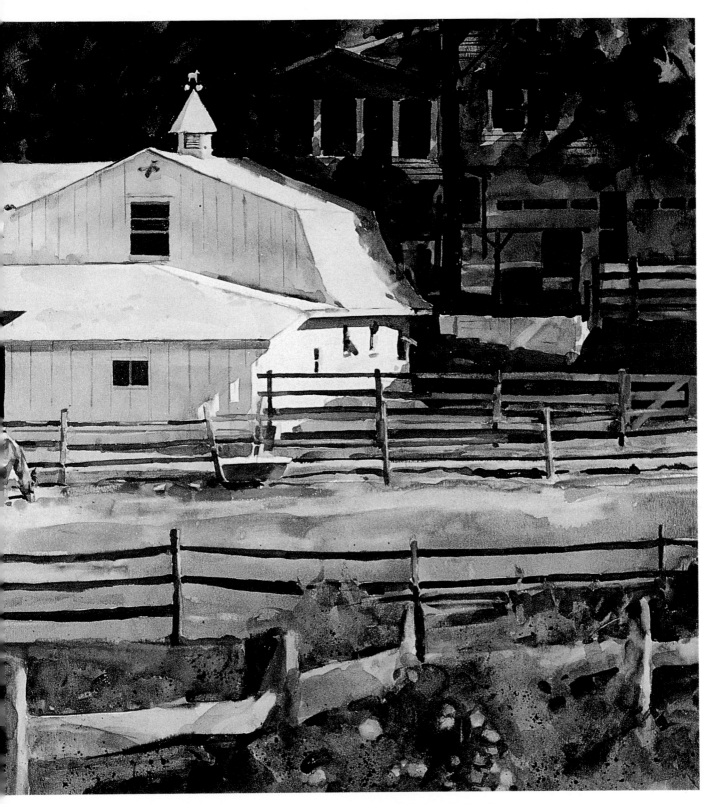

This painting was pronounced complete until it became apparent that the activity of the foreground and background was challenging the middle ground, which is the main focus of the painting. Sponging the foreground out of critical focus and laying washes over the background simplified and enhanced the painting.

A collection of source materials used for paintings, including snapshots, slides and sketches. You can choose to work from any or all of these on each painting. What's important is that you decide what you want and plan how to combine them.

Think Before You Paint

Before beginning to paint—whether working from slides or photographs in the studio and especially when working on location—go through a thinking process that is the key to painting smart. The old adage about spending 80 percent of your time thinking and 20 percent painting is a good one to remember. As John Pike says, "Think like a turtle, paint like a rabbit."

Ask yourself, "What am I trying to get across in this painting?" and "What do I want the viewer to feel when it is shown?" Then draw a series of thumbnails, experimenting with ways in which the principles of design can be used to create the best answers to those questions.

After trying out various ideas in a series of thumbnails, do a larger value sketch of the one you feel works best. Use a small 8-by-10-inch sketchbook and either a General's sketching pencil or some other graphite pencil with a large soft lead. Use whatever you are comfortable with. Sketch with large, loose strokes. You only want to determine the best pattern for the darks and lights.

The value sketch is a very important step in this procedure. In fact, getting the value pattern right is more important to the success of a painting than getting the colors right. By determining before you actually paint where your darks are going to be, you can

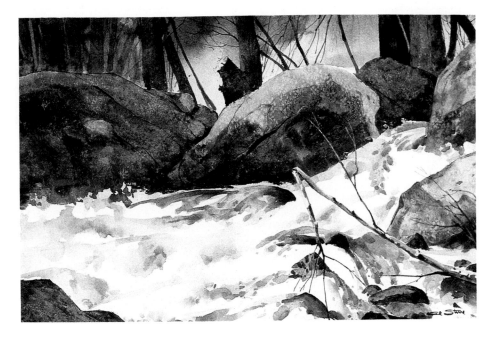

confidently paint darks with rich, strong colors when the time comes.

When you're satisfied with your value sketch, transfer your drawing to your painting surface using a simple grid pattern to help keep the proportions right. This grid pattern can be as simple as a horizontal and vertical line dividing the rectangle into equal quarters.

Generally, try to use only the lines you need and draw them as lightly as possible, so there aren't too many pencil lines visible in the finished painting. This also keeps the painting surface from getting greasy and soiled from fingerprints or damaged by erasures.

After doing a value sketch, you may wish to paint a small color rendering to decide which palette will best establish the mood. These may be about 6-by-9 inches, and some turn out to be lovely paintings.

Mists of the Hidden Falls
13" × 19", Al Stine, watercolor
collection of Mr. H. A. Royster

A painting is the result of a long thinking process that begins well before putting paint on paper, just as this rushing water has its source in the mountains high above.

Using a Viewfinder

A viewfinder is a simple tool that is invaluable when deciding which size of canvas to use and how to best compose a subject. A viewfinder made of two "L"-shaped pieces of cardboard can be adjusted to conform to any size canvas.

Use the viewfinder to frame possible subjects, moving it closer to or farther away from your eye to take in more or less subject area. You may also determine how much of the subject you want to include and in which format—horizontal, vertical or perhaps even square. Also use the viewfinder to establish a center of interest.

Before you begin to paint, use the viewfinder to establish reference points. Hold a slim brush against the viewfinder at the horizontal or vertical centers of the opening. These reference points determine where key elements of the composition lie in relation to each other and to the overall picture, and help establish where the horizon line is in relation to the horizontal center of the painting.

As you can see in the top picture, Calicoon Creek *offered opportunities for many different compositions—a horizontal version (bottom) eliminated the sky and tightly closed in on the foliage and creek.*

Next, a vertical composition included just the creek and trees in the painting.

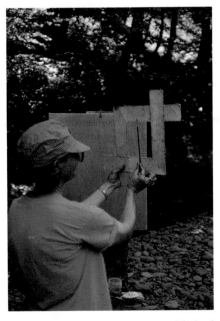

Here, reference points are established for the composition. A slim brush held against the viewfinder helped to determine which elements lay closest to the horizontal and vertical centers of the format.

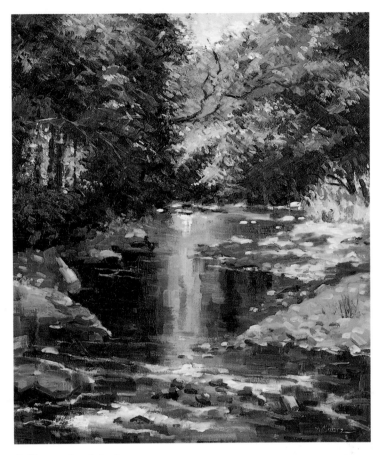

Calicoon Creek in Summer
24" × 20", Mary Anna Goetz, oil on canvas

Notice the dramatic effect created by the reflection of the sky and sunlit trees in the water and the way the dark shadows surrounded it. Note the differences between this composition and the first version in the viewfinder.

Step 1: A turpentine wash was applied, using ultramarine blue and cerulean blue for the sky, with sap green and alizarin crimson added to the blue for the rest of the canvas. Then the shapes were suggested more strongly with the same colors to indicate placement.

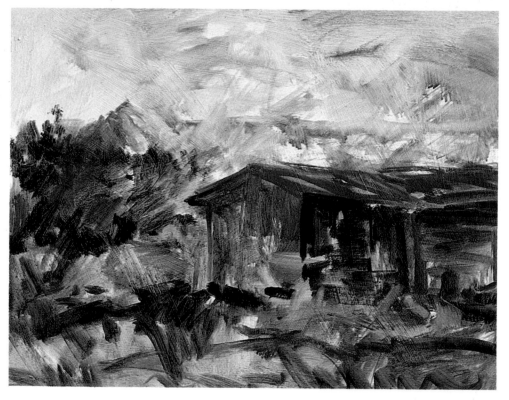

Step 2: The drawing phase was eliminated and more shapes were developed. The bushes in the middle ground were added and the building was defined with direct brushstrokes.

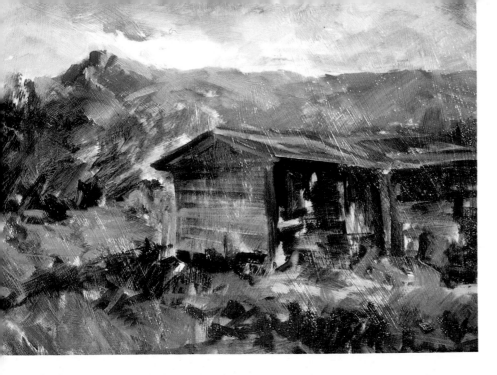

Step 3: Next, the horizon and foreground foliage were painted. You can see how the painting progressed from very loose and under-detailed to more controlled and specific. The dark of the doorway was broken up to keep it from being a dead spot. Sky colors were secured using cerulean blue and ultramarine blue. The clouds were white, toned to a rosy pink with cadmium red light.

Some light strokes to the foreground helped establish the focal point. These weren't solid brushstrokes; instead the color beneath was allowed to show through.

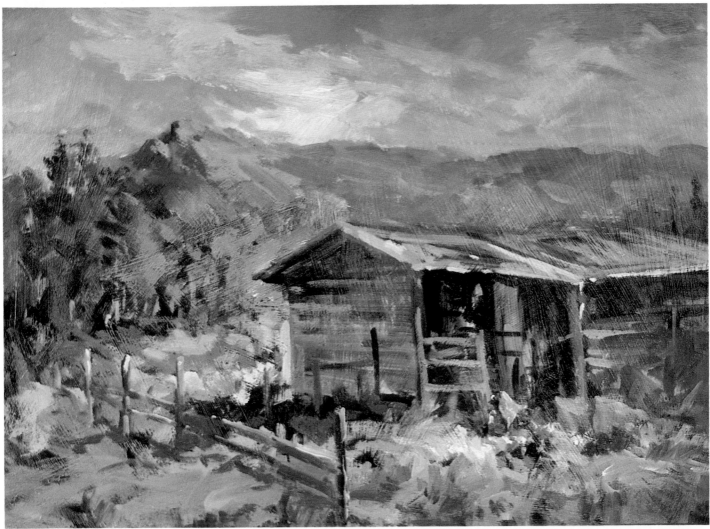

Early Morning on the Ranch
18" × 24", Joyce Pike, oil

Step 4: As the painting reached final resolution, the colors were adjusted to preserve the quality of light created by the sunrise. Those areas struck by sunlight were kept warm to contrast the cool shadows. Touches of blue sky were placed in the foreground and the red for the chickens was placed on the trees to tie the painting together.

USING COLOR
From Basics to Professional Color Secrets

The word *value* used in describing color means the lightness or darkness of the hue. Whether you say *sky blue* or *navy blue*, the hue is still blue, just the value is different. To lighten the value, add white. To make the deep value, add black. But adding black sometimes changes the hue; for example, black added to yellow does make it darker, but the yellow changes hue and becomes green.

Know the Value of Your Colors

In our Color-as-Value Chart at right, you see titanium white at value 1 become progressively darker toward black at value 7 as you move across the top row of squares from left to right. Each color also has its own row of squares (horizontally) and is painted in progressively darker values between value 1 (white) and value 7 (black).

Exercise Making a Color-as-Value Chart

By completing this chart, you will learn how to make any of these pigments lighter or darker without changing its hue. You will need titanium white, lemon yellow, cadmium yellow orange, cadmium red light, alizarin crimson, ultramarine blue, viridian green, raw umber, burnt umber and ivory black.

Procedure. On your palette, squeeze out about two inches of titanium white and about an inch of paint in each of the nine hues in the order in which they are given: white in the upper left corner of the palette, then lemon yellow, cadmium yellow orange, cadmium red light, and so on across the top to ivory black in the upper right corner. Don't crowd the colors on the palette; one color should not touch another.

Paint lemon yellow in its designated square under value 2—light, then cadmium yellow orange in its designated square, then cadmium red light, alizarin crimson, ultramarine blue, viridian green, raw umber, burnt umber and ivory black, each one pure, clean and unadulterated, in its square as printed on the chart.

Starting with the lemon yellow at the top, you will see it is already only one value away from white so don't do anything about mixing it to a *lighter* value. For the darker values, starting with the yellow, mix raw umber with it, first in *tiny* amounts, then more and more, darker and darker.

Squint very hard to compare your lemon yellow-raw umber mixtures with the gray values at the top of the chart. Do you have a value 3 mid-light and 4, 5 and 6? If not, adjust your mixtures lighter or darker. Paint the four lemon yellow values in their allotted squares on the top line. Complete the chart with the remaining colors.

It is not easy to mix color exactly to a precise value. *You have to squint hard to match a color value to a gray value.*

To lighten any of the oil colors, add white. To darken a color (lower its value) without changing its hue, you need to know the following:

Lemon yellow is lowered in value by adding raw umber.

Cadmium yellow orange is lowered in value by adding burnt umber.

Cadmium red light is lowered in value by adding burnt umber.

Alizarin crimson, ultramarine blue and viridian green are all darkened with black.

Raw umber and burnt umber are darkened with black.

VALUE 1 White	VALUE 2 Light	VALUE 3 Mid-light	VALUE 4 Mid-tone	VALUE 5 Mid-dark	VALUE 6 Dark	VALUE 7 Black
Titanium White (Pure)	Lemon Yellow (Pure)					
		Cadmium Yellow Orange (Pure)				
			Cadmium Red Light (Pure)			
				Alizarin Crimson (Pure)		
				Ultramarine Blue (Pure)		
				Viridian Green (Pure)		
					Raw Umber (Pure)	
					Burnt Umber (Pure)	
						Ivory Black (Pure)

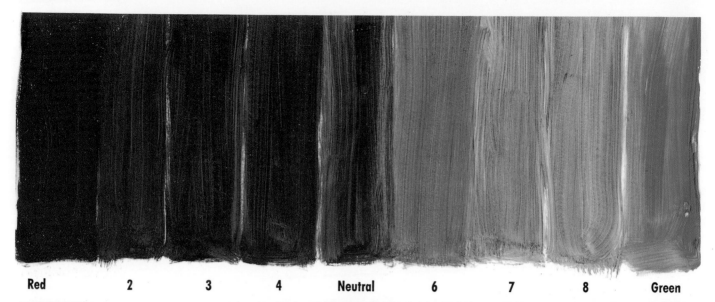

| Red | 2 | 3 | 4 | Neutral | 6 | 7 | 8 | Green |

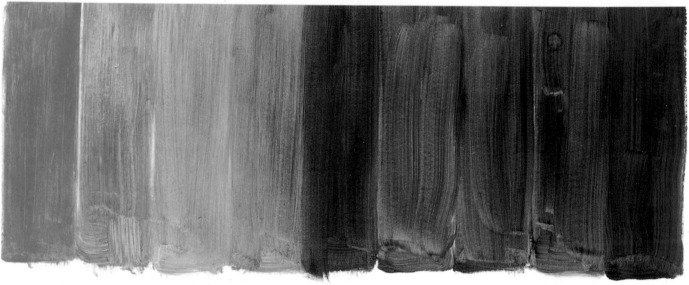

| Orange | 2 | 3 | 4 | Neutral | 6 | 7 | 8 | Blue |

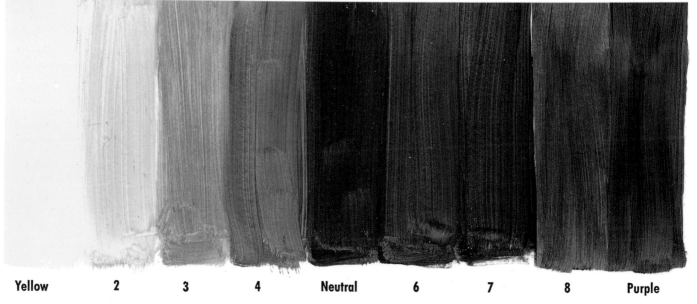

| Yellow | 2 | 3 | 4 | Neutral | 6 | 7 | 8 | Purple |

Basic Landscape Techniques

Mixing Colors

Neutral colors are important in landscape painting. Most colors are neutrals and add to the brilliance of the occasional pure hue used in a landscape. Use neutrals to prevent the unrealistic "fauve" look—unless that's the look you want.

Mixing complements is the best way to get neutral colors. Totally neutral mixtures are not always made by mixing 50 percent of one color with 50 percent of its complement. For example, it takes only a very small amount of purple to neutralize lemon yellow, but it would take quite a bit of yellow to neutralize the purple. It's usually easiest to start with the *lightest* color when making a mixture.

Color Temperature

Most all artists believe that yellows and reds are warm colors, and blues and greens are cool colors. Of course, this is an oversimplification; every color can be warmed or cooled. Yellows get warmer as they go toward red and cooler in the other direction on the color wheel, toward green. Even reds can be warmer going toward yellow and cooler leaning toward blue. Each color is affected by whatever color is adjacent to it. Sure, a red is a red, but as an artist, you are in control—you can alter red dramatically by the hues, values, intensities and temperatures of color you place next to it.

Red

Red and Black

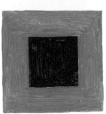
Red and Orange

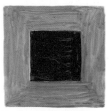
Red and Purple

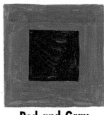
Red and Dark Green

Red and Gray

Enhancing Intensity of Yellow

Yellow

Yellow and Black

Yellow and Green

Yellow and Orange

Yellow and Purple

Yellow and Gray

Making Colors More Intense

By using complementary colors, you can make any hue appear *more* intense. For example, to make red appear its most brilliant, surround it with its complement, green. The following exercise involves painting squares within squares to explore this color phenomenon.

There is a half page of squares for each primary and secondary color. Paint specific colors in the outer squares surrounding each of the six hues and then study the results. You will see the way the same color *appears* to change from one square to the next, depending on the surrounding hue.

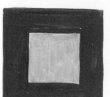

Green and Blue

Green

Green and Black

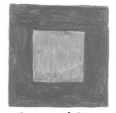

Green and Red

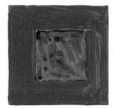

Green and Yellow

Green and Gray

Enhancing Intensity of Purple

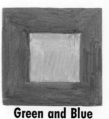

Purple and Red

Purple

Purple and Black

Purple and Yellow

Purple and Blue

Purple and Gray

Enhancing Intensity of Blue

Blue and Green

Blue and Black

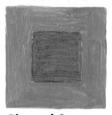

Blue and Orange

Blue

Blue and Purple

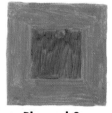

Blue and Gray

Enhancing Intensity of Orange

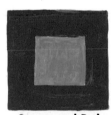

Orange and Red

Orange and Black

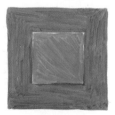

Orange and Blue

Orange

Orange and Yellow

Orange and Gray

Designing With Color

To paint directly, with vibrant color and without overworking your canvas, *you have to plan ahead*. Composition is arranging everything in a painting—the lights and darks, the lines and shapes, the warm and cool colors—so the composition does what you want it to. You can arrange these things so the picture is pleasing and attractive, or you can arrange them so it is disturbing and unbalanced. You can arrange them so the viewer's eye circulates around the picture and stays within its borders, or you can arrange them so the eye enters and leaves the painting just where you want it to. The choice is yours.

How you make various choices is your opportunity for self-expression. How your composition works is one of the most important ways you make a painting your very own statement. The mood or emotional effect will be the result of how you compose your painting. It's how you express your own ideas, moods and emotions. Composition makes your painting a unique creation.

Color Comps

The color comp is a small (2-by-3 inch) abstract study of color. It helps you make important decisions about color for a painting without getting caught up in painting *something*. Doing a color comp is also an occasion when learning can be just plain fun. Each time you do one, you will become more familiar with how colors and values can be used in painting.

Here are some examples. The first set has red as the dominant hue, with red-orange and red-purple as adjacent hues. Green is the complement.

The one on the left is high key, which means the painting is mostly all light with a small amount of dark. The one on the right is low key: a dark painting with a small amount of light. Both examples include discords, which are equal amounts of the remaining two paints on the triangle, used in small, equal portions, as clearly shown in the example. With red the dominant hue, the two discords are blue and yellow. Also in the examples is a touch of the complement in a pure form. This is

optional, since the complement has already been used through the painting as a graying agent.

For the second set of color comps, blue is the dominant hue, with blue-purple and blue-green as adjacent hues and orange as the complement. The discords are red and yellow.

The third example was planned with yellow as the dominant color. The three primary colors in these examples show the obvious temperature changes. A painting should not be equally warm and cool, or equally dark and light. The dominant color need not be a primary. It could be a secondary color, or even an intermediate color between primary and secondary. As the triangle of analogous colors turns within the color wheel, it always shows us the dominant hue, its complement and the related discords.

Red dominant

High key

Low key

Blue dominant

High key

Low key

Yellow dominant

High key

Low key

Using Color to Unify a Composition

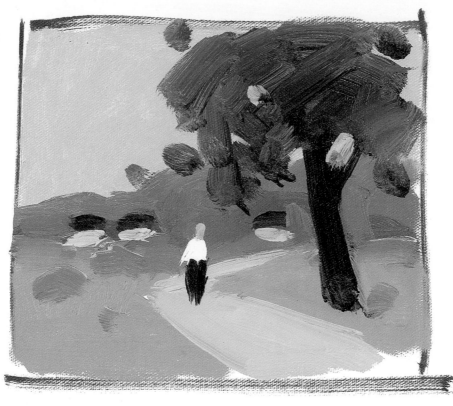

Limiting Your Palette

Black

Viridian

Yellow Ochre

Using a Complement as a Center of Interest

Burnt sienna, cadmium red light, cadmium orange, cadmium yellow medium, yellow ochre, and cerulean blue.

Ultramarine blue, cobalt violet, Thalo red rose and cadmium yellow pale.

Contrasting Temperature Changes

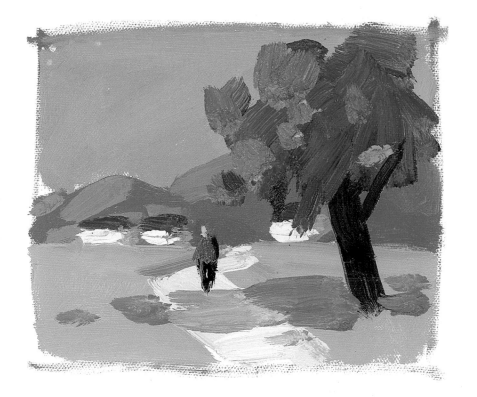

Brown madder

Thalo red rose

Cadmium red light

Cadmium yellow medium

Cadmium yellow pale

Permanent green light

Viridian

Cerulean blue

Ultramarine blue

Emphasizing Decorative Patterns

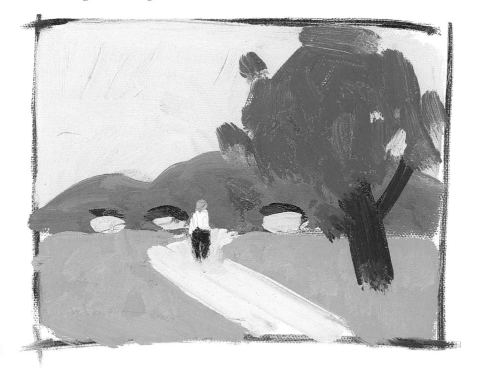

Black

Cobalt violet

Cadmium red light

Cadmium orange

Cadmium yellow pale

Permanent green light

Thalo blue

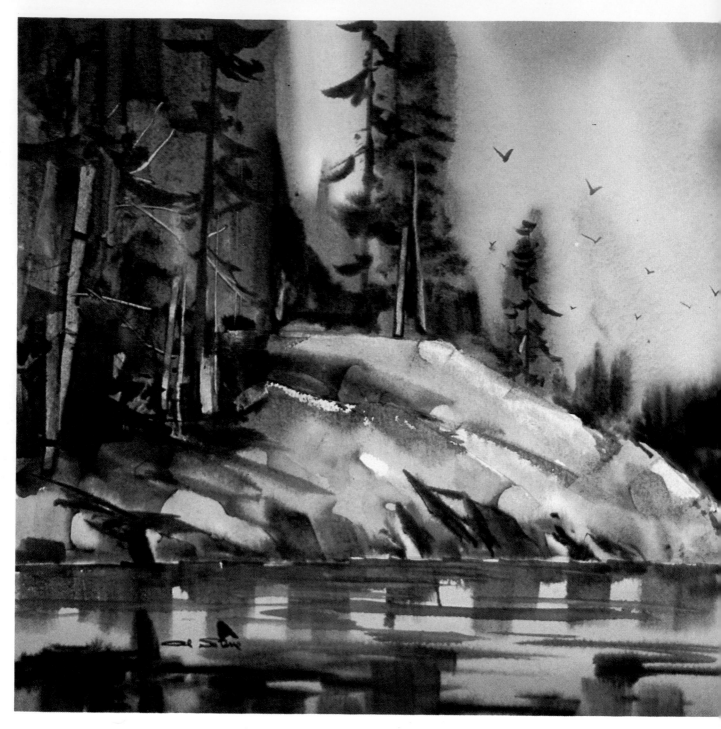

This painting was done with just three colors—indigo blue, raw sienna and burnt umber. This is a good example of the wide range of colors you can get from a limited palette. It really is easier to paint with three colors than with six or seven, and you'll find it much simpler to maintain color harmony throughout the painting.

Lake Reflections
13" × 19", Al Stine, watercolor

Using a Limited Palette

Many students load up their palettes with all the pretty colors they can and then attempt to use all of them in their first painting. Soon they feel overwhelmed and confused by color. Their paintings become muddy, they have difficulty matching the colors they see, and they waste paint. Limiting your palette actually opens up unlimited opportunities for color harmony and control.

Limiting your palette offers several advantages. First, using only a few colors in the beginning gives you the chance to learn what those colors can do. Limiting your palette certainly won't limit how much you can learn about color. Second, a limited palette makes achieving color harmony easier. You will be using colors that have a strong familial resemblance, because they will share the same "parent" col-

ors. Color balance is easier to attain when you are using a few related colors than when you are using many different colors. Third, a limited palette encourages you to make the most of value pattern and contrast, playing light against dark. You can't rely on lots of pretty colors to save a painting that has weak values. Finally, working with a few colors enables you to concentrate on playing warm against cool colors, saving your whites, and using strong colors against grays.

To see the amazing results that can be obtained with a limited palette, start with just two colors. Do several different paintings with just these colors. When you are comfortable with two, add another color and do several more studies. And when you're comfortable with three, try four, and so on, adding one color at a time.

Color Harmony

Color is the first thing that attracts viewers' attention, and the first thing that viewers respond to when they see your painting.

Color harmony is an important concept when you're planning the colors for a painting. It is achieved by balancing a dominant hue with its opposite (or complementary) color and adding accents of discordant colors. Color harmony begins with the selection of one hue that will be the dominant, or most used, color in the painting. In a landscape, green may be the dominant hue, but you can mix many different greens from the pigments on your palette. Colors closely related to green, such as blue green or yellow green, add variety but don't conflict with the green.

However, a painting with only greens and colors closely related to green would get boring very quickly. So the painting needs to be relieved by a color that is the dominant color's opposite—in this case, red—but the red must be carefully balanced with the green. You want just enough to keep the green from getting dull, but not so much that it fights for the viewer's attention. Perhaps in a landscape with lots of greens, a small red flower would break the monotony.

To achieve very pleasing color balance or harmony, add a bit of some colors. In the example, the dominant

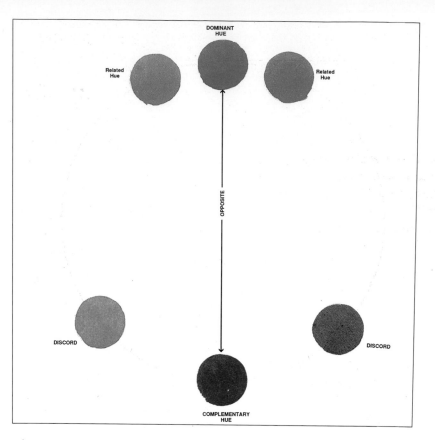

color, green, and the colors closely related to it are balanced by the complement, red. A little orange and purple would add slightly discordant but entertaining notes to the painting—a little spice, in other words. So you can see, color harmony is the balance of a dominant color that unifies the painting with its opposite, which adds excitement, enhanced by touches of the other hues.

The play of contrasts is an important key, but it doesn't happen automatically. You have to think about it. Develop the habit of looking at your painting in terms of light and dark, cool and warm.

This color wheel shows the relationships of the dominant color and close neighbors with its opposite color and two discordant colors. Using colors in the right amounts will help you achieve color harmony in your painting. Try making some of these color wheels with different dominant colors to help build your feel for color harmony.

Beautiful Grays

Don't think of gray as being merely the mixture of white with various amounts of black. Such a gray is very dull. Instead think of grays as all the rich and subtle neutrals that can be mixed from the bright and intense colors of the palette. The basic formula for gray is to mix a pure color with varying amounts of a color opposite in hue or color temperature. How much or how little of the opposite color you use determines the special character of the resulting gray. You can mix warm or cool grays or green, brown or purple grays just by varying the basic formula. Some mixtures include French ultramarine blue, which makes appealing grays when blended with earth tones such as burnt sienna and burnt umber. Van Dyke brown, a brown even deeper and darker than burnt umber, makes lovely grays—some warm and some cool, depending on how the brown is mixed with French ultramarine blue; this combination is good for creating a background forest in snow scenes. Winsor green mixed with cobalt violet will give you grays that sparkle (and lovely mauves, too). And if you need a dark, almost black, color that still has a lot of life, mix Winsor green with alizarin crimson.

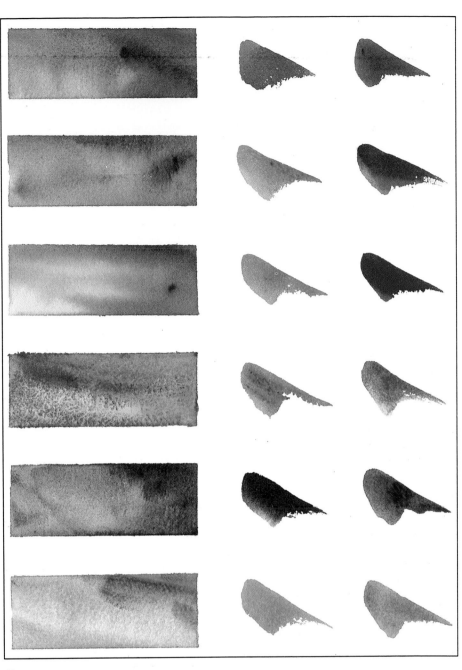

Grays:
1. *Winsor blue and burnt sienna*
2. *Winsor green and burnt sienna*
3. *Winsor green and alizarin crimson*
4. *Winsor green and cobalt violet*
5. *French ultramarine blue and burnt umber*
6. *Cerulean blue and raw sienna*

Using Color Guides

Make up color guides to get the color schemes you plan to use in your paintings. These color guides consist of swashes of the various colors you think you want to use, layered and grouped so you can see how they actually work together.

What's a color scheme? It's the colors you choose to establish an overall mood for your painting. To create mood, consider the time of year and the amount of available light, from bright sunlight to heavy overcast. For example, use lighter, warmer colors (such as yellows or oranges, green with a tint of yellow, or gray with a hint of red) for a sunny scene or to create a happy mood. It would be foolish to paint a stormy sky with warm, happy colors. Instead choose cooler, darker, more sober colors (such as green, blue, purple, or gray) for stormy scenes.

You will occasionally need to vary the color scheme in a painting. If you were painting a forest scene, for example, and wanted to communicate a sense of moodiness or brooding, it would be a mistake to use warm colors in the background. Warm colors would destroy the depth and mystery re-

FRENCH ULTRAMARINE BLUE,
ALIZARIN CRIMSON, RAW SIENNA,
BROWN MADDER ALIZARIN

FRENCH ULTRAMARINE BLUE,
RAW UMBER, BROWN MADDER
ALIZARIN

FRENCH ULTRAMARINE BLUE,
CADMIUM RED, BURNT UMBER

FRENCH ULTRAMARINE BLUE,
RAW SIENNA, BROWN MADDER
ALIZARIN

FRENCH ULTRAMARINE BLUE,
BURNT SIENNA, WINSOR GREEN

FRENCH ULTRAMARINE BLUE,
WINSOR GREEN, RAW SIENNA,
COBALT VIOLET, ALIZARIN
CRIMSON

This is a series of color guides showing the exciting colors you can get with just three to five colors. This panel used French ultramarine blue as a base—the first color put down, into which all the others are mixed.

Basic Landscape Techniques

quired to convey such a near mystical feeling.

You may also use aerial perspective to establish distance, making distant objects bluer and foreground objects warmer and darker.

Save the color guides that you do and refer to them constantly. After you have developed many color schemes of your own in this way, you will have a storehouse of information ready to solve your color problems. For instance, you could look at one of your color guides, select a beautiful, lively gray, and determine if it should be placed next to a stronger warm or a cool color.

As illustrated in the sample color guides you see here—using from three to five colors in each—great color variation is possible even with a limited palette. Again, having only a few colors to choose from simplifies the process of achieving color harmony. Experiment with your own selections of color, but remember that you should have at least one warm and one cool color playing against each other. By contrasting warm with cool, dark with light, and grays with stronger colors, you can make your colors truly "sing."

CERULEAN BLUE, CADMIUM YELLOW PALE, BURNT SIENNA, FRENCH ULTRAMARINE BLUE, CADMIUM RED

CERULEAN BLUE, COBALT VIOLET, WINSOR GREEN, BURNT SIENNA, ALIZARIN CRIMSON

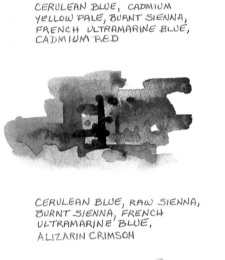

CERULEAN BLUE, RAW SIENNA, BURNT SIENNA, FRENCH ULTRAMARINE BLUE, ALIZARIN CRIMSON

CERULEAN BLUE, WINSOR GREEN, BURNT SIENNA, CADMIUM RED

CERULEAN BLUE, RAW UMBER, BURNT SIENNA, FRENCH ULTRAMARINE BLUE, CADMIUM ORANGE

CERULEAN BLUE, ALIZARIN CRIMSON, BURNT SIENNA, FRENCH ULTRAMARINE BLUE, WINSOR GREEN

This time cerulean blue is the base for a series of color guides. Some French ultramarine blue was added only to achieve darker color.

Sample Limited Palettes

Two Colors

Let's start with two colors. Working with just two colors frees you to think about saving your whites, getting good value patterns and creating color harmony. Not all two-color combinations will work this way; one color should be cool and the other warm. The cool color will be useful for painting atmospheric conditions and skies, particularly the cool tones in the distance. The warm color will evoke the warmth of the earth in the foreground. French ultramarine blue and burnt umber, for

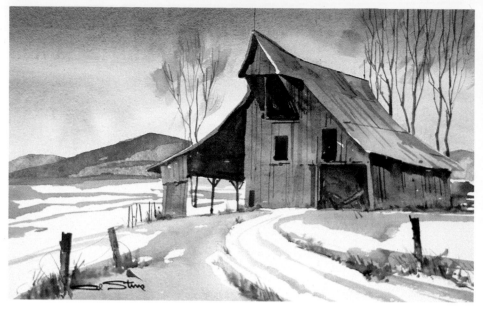

January Surprise, 9″ × 14″, Al Stine, watercolor

Only French ultramarine blue and burnt umber were used in this painting. Cool color mixtures were used for the sky and the distant mountains, and the warmer colors for the barn, posts and grasses in the foreground.

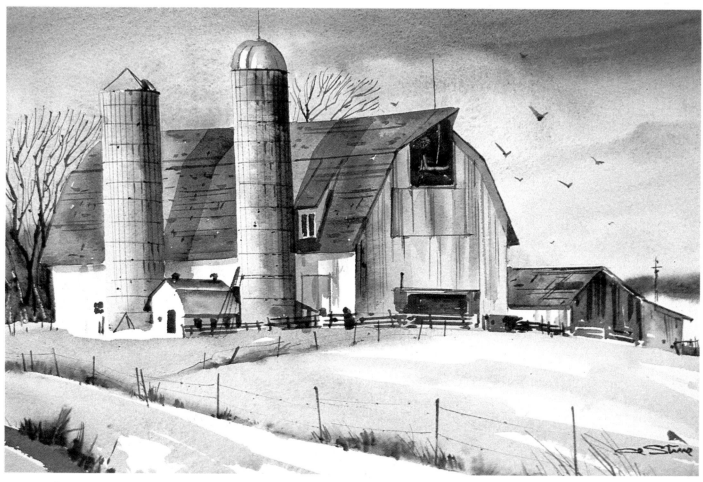

Winter White
9″ × 14″, Al Stine, watercolor

This painting was also done with French ultramarine blue and burnt umber. The blue was used for the sky with a little burnt umber added at the top. The warmer tones were saved for the barn and the strip of grass along the fence.

example, can give you a range from blue to gray to brown in both warm and cool tones.

Three or Four Colors

After you have done a number of paintings with the two-color palette, add one more color to ultramarine blue and burnt umber. Since you could not mix a green with those two colors, add Hooker's green dark to the palette.

This green will provide green for leaves and shrubbery, expanding the range of landscape subjects you can paint with just a few colors. Adding green to the other two colors will make them more interesting as well, and add more excitement to the painting.

To avoid the muddy look that mixing colors on the palette can create, make separate puddles of the three colors on the palette and do the mixing on the paper. Let the colors intermingle but not blend.

A three-color palette of indigo blue, raw sienna and burnt umber gives a wide range of warm and cool grays, beautiful greens (without using a green) and good, punchy darks. Indigo blue looks almost black when pressed from the tube; remember that it makes a lovely color when diluted with water.

As you can see, you can paint almost anything you want with the three colors in your palette. However, if you wanted to paint a red barn or capture the colors of an autumn afternoon, you would be out of luck. So now it is time to add cadmium red. While you can do a lot with the colors you've worked with so far, different combinations can give you better results.

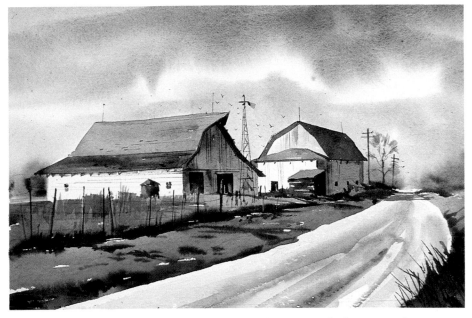

French ultramarine blue, burnt umber and Hooker's green dark were used to capture the green of the field. Adding a contrast color, like the green here, puts some spice in your painting. Look at the impact of adding green to the sky colors on the buildings.

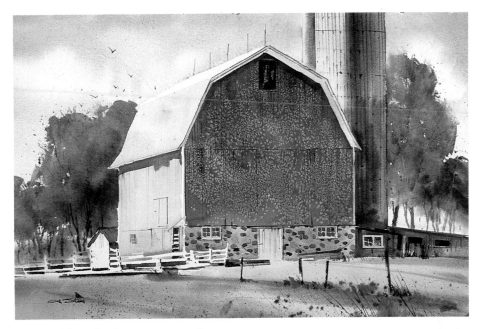

Sunlit, 13" × 20", Al Stine, watercolor

This demonstration used the same three colors as in the previous demonstrations, adding cadmium red to the barn. The light side of the barn was using a very light wash of cadmium red, warming the color up at the bottom with a hint of burnt umber to show the reflections of the earth. On the shadowed face of the barn, cadmium red with French ultramarine blue was used and, while still wet, salt was sprinkled in to get some added texture. A mixture of cadmium red and burnt umber was brushed on the foreground area.

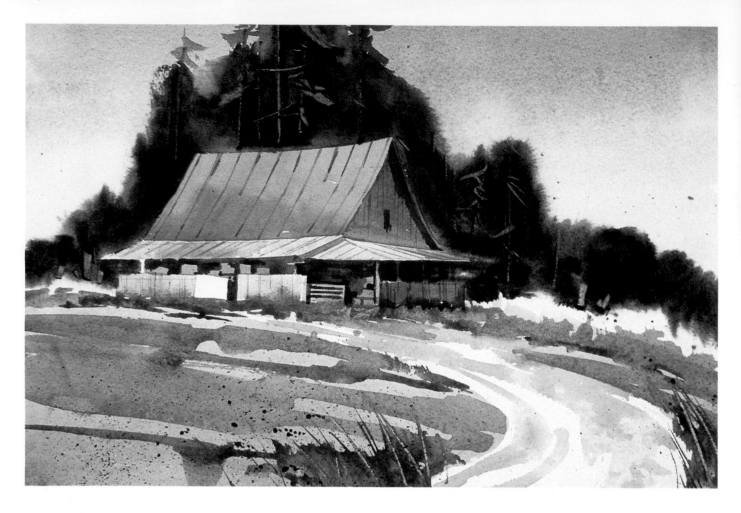

Five Colors

Once you understand the advantages of working with only a few colors and learn how to make the most of them, you will begin to view a palette crowded with colors as a burden, not an opportunity. Now that you have worked with four colors, it's time to add one more. Since there is a limit to your ability to match exactly the colors that you see with only five colors on your palette, it becomes essential to think in terms of light against dark and warm against cool. If you make the values and color temperatures work right, your actual color choice is of secondary importance. However, the reverse is not true:

The painting won't work, no matter how closely you've matched the colors on the painting to what you see, if the value and temperature contrasts aren't right.

This painting shows that you can retain color harmony and a strong play of light against dark and cool against warm using five colors. The light, warm roof of the barn contrasts the cool, dark colors of the background forest. The warm foreground is overpainted with cool shadows; darker and warmer weeds are, in turn, painted over the cool shadows. Throughout the entire painting cool works against warm and dark against light.

For this painting, French ultramarine blue, cerulean blue, raw sienna, burnt umber and brown madder alizarin were used for variety. The painting was started at the top with a mixture of the two blues, then cerulean blue only, and finally a pale wash of raw sienna. While the paper was still damp, the dark forest was painted in using the French ultramarine blue and burnt umber. The first color on the foreground—a cool, grayed raw sienna—was painted in while the forest area was drying. The roof of the barn was painted with a mixture of burnt umber and brown madder alizarin after the background trees had dried. The warm foreground grasses were painted with brown madder alizarin and burnt umber.

Basic Landscape Techniques

Applying the Limited Palette

The paintings you'll find on this and the following pages show what can be achieved using only four to six colors at a time. Add to or subtract from these colors and make up your own color schemes from the color guides that you have created. Have fun painting a bunch of 4-by-6 inch roughs for practice.

Don't stop with just these small paintings, however. Painting smart is not only learning by doing, but also learning from what you have already done. Save your practice paintings and study them. Decide what you like or don't like about them; think about what you might do differently the next time. Take the ones you feel are gems and see what colors you like and how they work together. Then take those colors and try them out on a larger painting. Building on what you've already learned will help take away that old bugaboo of not knowing what colors to use.

A Warm Snow Scene (Alone in the Snow)
9" × 14", Al Stine
collection of Laura K. Hollenbeck

A palette of burnt sienna, burnt umber, cerulean blue and Payne's gray creates a completely different mood simply by warming up many of the colors. The clouds are Payne's gray and warmed by adding burnt umber. Cerulean blue and burnt sienna were used to paint the snow. The large foreground tree is Payne's gray, burnt umber and Hooker's green dark. More watercolors by Al Stine are shown on pages 72-73.

A Cold Winter Snow Scene. *Compare this scene with the one you saw on page 71. A cool palette was used for this painting: raw sienna, Payne's gray, French ultramarine blue, cerulean blue and Hooker's green dark. In the earlier painting burnt umber and Payne's gray were used for warm gray clouds. To get cool gray clouds here, French ultramarine blue was used with the Payne's gray. The background trees and the pine trees were done with Hooker's green dark, Payne's gray and raw sienna. The same colors were repeated in the fence but with more raw sienna added to warm up the mixture.*

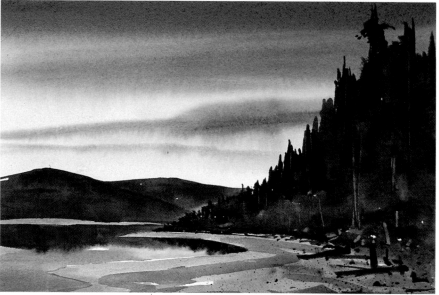

A Sunset Scene. *A warm palette of raw sienna, cadmium orange and burnt sienna was used for this sunset. For dark, cool contrast notes cerulean blue and Hooker's green dark were added. Over a pale wash of raw sienna, the sky was painted with a mixture of burnt sienna, cadmium orange and a little cerulean blue, beginning at the top. The distant mountains were painted with Hooker's green dark. The same mixture was used for the closer trees but made darker in value and warmer, since these trees are nearer to the viewer.*

A Fog Scene. *Raw sienna, Payne's gray, cerulean blue, Hooker's green dark, burnt sienna and cadmium yellow pale were used here. Using six colors for this painting helped give a greater range of grays, blues, greens and browns. The painting is rather somber but ethereal, so cool colors predominate with only gentle warm notes. The colors are still closely enough related to preserve color harmony throughout the painting. The colors gradually warm from the distant headland to the foreground rocks.*

Basic Landscape Techniques

A Coastal Scene (Pacific Coast)
9″ × 14″, Al Stine
collection of Laura K. Hollenbeck

A palette of raw sienna, Payne's gray, cerulean blue, alizarin crimson and burnt umber offers a lot of warm-cool, dark-light contrasts. The sky was painted using a pale wash of raw sienna, the clouds with Payne's gray for contrast. The distant formations and the beach were painted cerulean blue. The foreground rocks were painted using the same colors as the other rocks, but the mixture was warmed up to make them appear nearer to the viewer.

A Sunlit Beach. *Here's a warm, happy painting done with a palette of cerulean blue, raw sienna, burnt sienna and French ultramarine blue. Although plenty of cool and dark notes were included for contrast, even those are slightly warmed to keep them in harmony with the rest of the painting. For example, the lighthouse was painted with French ultramarine blue and cerulean blue with raw sienna used to warm the shadows slightly.*

A Scene With Autumn Colors. *For this painting, the palette consisted of Hooker's green dark, cadmium red, burnt sienna, raw sienna and cerulean blue. The trees were painted next with various mixtures of burnt sienna, Hooker's green dark, raw sienna and cadmium red. The water was done with the colors used for the sky; the same colors were used for the trees as for their reflections in the water. The darker reflections were added with deeper values of cerulean blue and raw sienna.*

Chapter Six
CREATING DEPTH
Capturing the Essential Illusion

Talking about putting depth in your painting is a bit different from talking about color, backgrounds or negative space. While art elements like color, line and value are really there, depth is simply an illusion created by using the elements just mentioned.

The illusion of depth in a painting is created by imitating one or more of the seven observable ways the eye perceives depth in nature. The first two of these observations are: 1.) as space recedes, *objects that are close overlap the objects that are farther away*, and 2.) as space recedes, *objects appear to get smaller the farther away they are*. These are the principles of linear perspective.

In *Mountain Hamlet* (at right) the country store in the foreground overlaps three of the buildings in the background. The buildings behind the country store are also noticeably smaller, indicating they are farther away. If these two principles were not working properly, the painting would seem flat no matter how well the other principles were handled.

Aerial Perspective

It is not necessary to alter or exaggerate the two principles of linear perspective. However, the remaining five principles—those of aerial perspective—must be exaggerated in the painting. In nature they are so subtle they may go completely unnoticed. If this artistic overstatement is done well, it will appear natural and the viewer won't be aware of it. These principles are: 3.) as space recedes, *detail is lost*; 4.) as space recedes, *edges get softer*; 5.) as space recedes, *color becomes cooler*; 6.) as space recedes, *contrast between values diminishes*; and 7.) as space recedes, *color diminishes in intensity*. This last principle is a variation on the fifth principle, that color becomes cooler with increased distance. It is not as reliable as the other six.

To organize the exaggeration of these last five principles, divide the space into planes. Planes are divisions of space in which objects at roughly the same distance from the eye are grouped together. Objects close to the eye are grouped into the foreground plane. The most distant objects are grouped into the background plane. Objects at an intermediate distance between these two extremes are grouped into the middle ground plane. In the painting *Rolled Hay* lines are used to divide the space into foreground, middle ground and background. The single most consistent mistake students make is taking a shortcut and skipping the use of a line to separate the planes.

Treat the foreground and background as at opposite ends of the scale for each of the five different principles. For example, using the principle that detail is lost as space recedes, the background is at that end of the scale where there is little or no detail. The foreground is at the opposite end of the scale where there is detail. The middle ground is the transition between these two. On the edges scale, use some hard edges in the foreground and only soft edges in the background. Use the warmest colors in the foreground and keep the background cool. Create the greatest contrast between values in the foreground by having the darkest darks and the lightest lights there.

Mountain Hamlet
33"×33", Doug Dawson, pastel
private collection

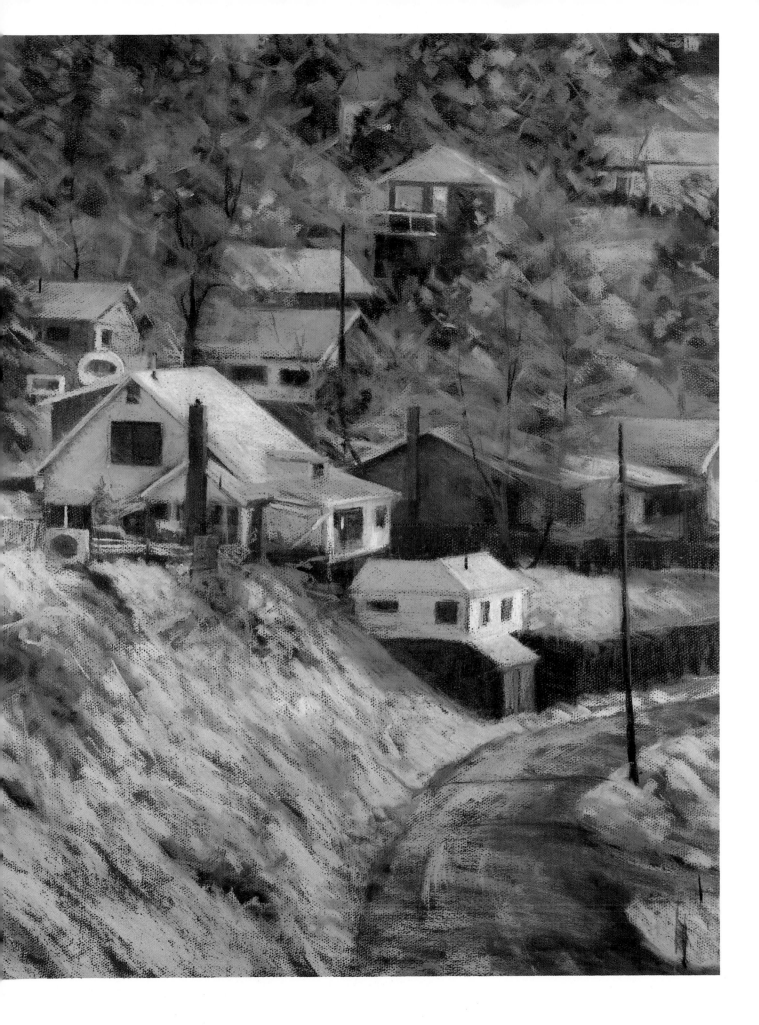

Step 1: The space is divided into three planes. The lower line separates the foreground and middle ground. The hay bundle and fence are visualized as part of the foreground and sitting right on this line. The upper line separates the middle ground and background. The center of interest is often placed on the line separating the foreground. This allows the artist to contrast the center of interest against the change in color, edges, detail and contrast in the other planes.

Step 2: The pattern of dark shapes in the foreground and background planes have been blocked in using the same color pastel. According to the principle of diminishing contrast, the darkest darks should be in the foreground if possible. The darks in the background will be lightened as the painting proceeds.

Step 3: The sky was blocked in with a yellow color, bringing part of it down over the background. This lightened part of the background and softened the edges where the background meets the sky. The background was blocked in with an Indian red, a red and a violet. The Indian red was used where the colors will encircle the setting sun. The principle that color gets cooler implies that if colors this warm are in the background, then touches of even warmer color (yellow oranges or yellows) will have to be used in the foreground.

Step 4: The middle ground and foreground were blocked in with the same two colors: a dark green (olive green) and a lighter yellow-green (cadmium orange). The two planes were separated by the artist by using these two colors in different proportions. More of the dark green was used in the foreground and more of the yellow-green in the middle ground. This is the reverse of the order these colors should be in if color is getting cooler as it goes back in space.

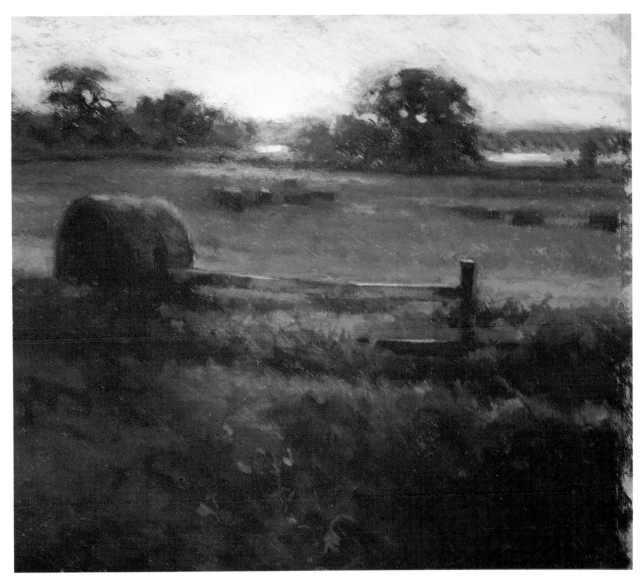

Rolled Hay
17" × 19", Doug Dawson, pastel
collection of Drs. Laura and Hubert Thomason

The artist corrected the color scale, making sure that the yellowest greens were in foreground vegetation. The warmest warms are also in the foreground, in the touch of yellow on the top of the fence rail and the yellow-orange on the top of the hay roll. The rest of the darks in the background were eliminated so that none would be as dark as the darks in the foreground. The edge separating background and sky was further softened while the edges of the fence and hay roll were sharpened. The textures in the foreground give the illusion of detail in the grass, fence and hay roll. The background and middle ground shapes are simple and devoid of detail.

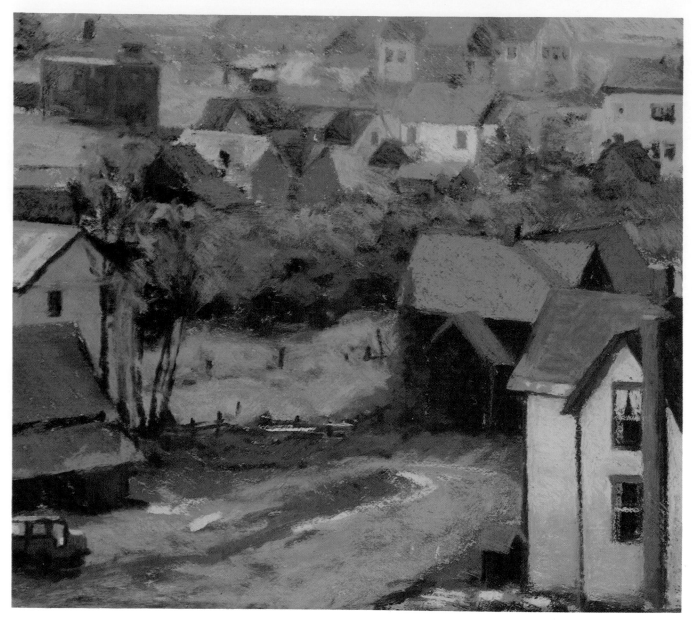

Village Road
21" × 23", Doug Dawson, pastel
collection of Anne & David Kleinkopf

The only details in this painting that distinguish the foreground from the background are the detail of the jeep on the left, the curtains in the windows on the right, and the fence posts along the upper edge of the foreground plane.

These pencil illustrations, and the ones on pages 80-81, show the line separating foreground and background.

Basic Landscape Techniques

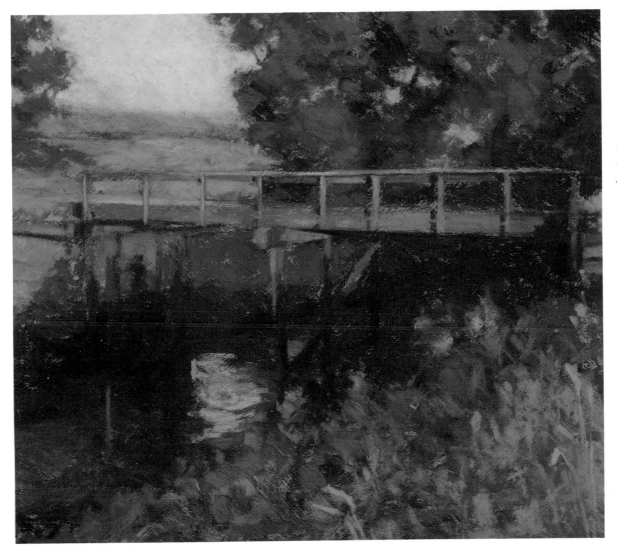

Canal Bridge
22" × 24"
Doug Dawson
pastel

Detail Is Lost

As space recedes, *detail is lost*. This happens for several reasons, mainly because most of the time your eyes are focused on what is close, not what is far away. A second reason you see less detail at a distance is because the image you see is made up of thousands of dots of value and color, much the way a printed image appears under a magnifying lens. The amount of detail you can see is limited by the number of dots that make up the image. At a certain point the details get so small they slip between the dots.

Just a few carefully placed details in the foreground give the illusion of detail. In the painting *Village Road* the smallest shapes used in the background, the windows and chimneys, determined the degree of detail needed in the foreground. Since the windows and chimneys in the background are visible, details must be implied within the windows or chimneys in the foreground.

Edges Soften

As space recedes, *edges get softer*. This is really a variation on the principle just described. Edges are really a type of

In Canal Bridge *the sky flows into the edge of the background plane, softening at the horizon. One color was painted into the other, causing the edge to be softer. A transitional value of another color could have been painted between the two shapes to soften the edge. A third approach is to scumble across the edge with one color. That is similar to the technique here except that scumbling results in an edge that is softer because it has been broken up in an irregular way.*

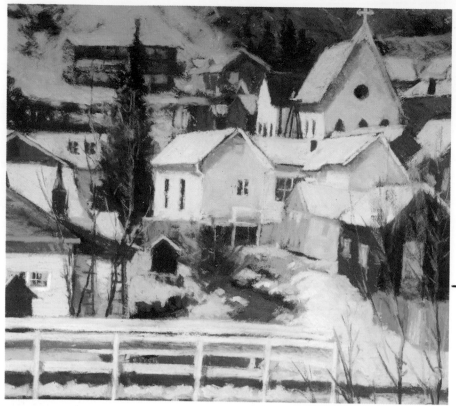

detail that gets lost as space recedes. Edges get softer because the farther away they are the more out of focus they are likely to be.

Conversely, when your eyes are focused on the background, the foreground is soft and out of focus. A painting with sharp edges in the background and soft edges in the foreground looks unfinished. In *Canal Bridge* the background shapes are all soft and diffuse.

Colors Become Cool

As space recedes, *color becomes cooler*. This happens because the air acts like a pair of blue sunglasses filtering out the warm light. The farther away an object is, the more air between you and that object, and the more the air behaves like sunglasses. Treat the foreground as if you are wearing no sunglasses at all and the middle ground in a manner halfway between these two extremes, as if you are wearing light blue sunglasses. The shift in color from warm to cool is predictable based upon the order in which different colors of light are filtered out. Yellow is lost first, then orange, then red, green, violet

and, last of all, blue.

When speaking of depth, consider yellow the warmest color, because it is the first filtered out by the air as objects recede. When you are not talking about this principle, however, and use the term "warm color" in a general sense, think of orange and red-orange as the warmest colors because they evoke more the feeling of heat.

In *Silver Plum* warm yellows, red and oranges are used in the foreground and only blues and greens in the background. This gives the painting a strong dramatic quality of light. There really isn't a middle ground, just a well-defined foreground and a background. A middle ground often isn't planned. It evolves naturally as the transition between these two planes.

Contrast Between Values Diminishes

As space recedes, *contrast between values diminishes*. This means that the light values get a value or so darker and the dark values get several values lighter. The result is that the contrast between them decreases. The reason

Silver Plum
22" × 24", Doug Dawson, pastel
collection of Susan J. Brookman

In the painting Silver Plum *the space is divided into two planes. There was little noticeable difference between the colors in the background and the colors in the foreground. If anything, there was more of a value difference than a color difference. The angle of the mountain behind the town caused the snow to look slightly darker in value. The shift in color was exaggerated to make the separation in plane more dramatic. All the snowy shapes were painted a blue-green in the background and the use of all the yellows, oranges and reds was restricted to the foreground shapes.*

Basic Landscape Techniques

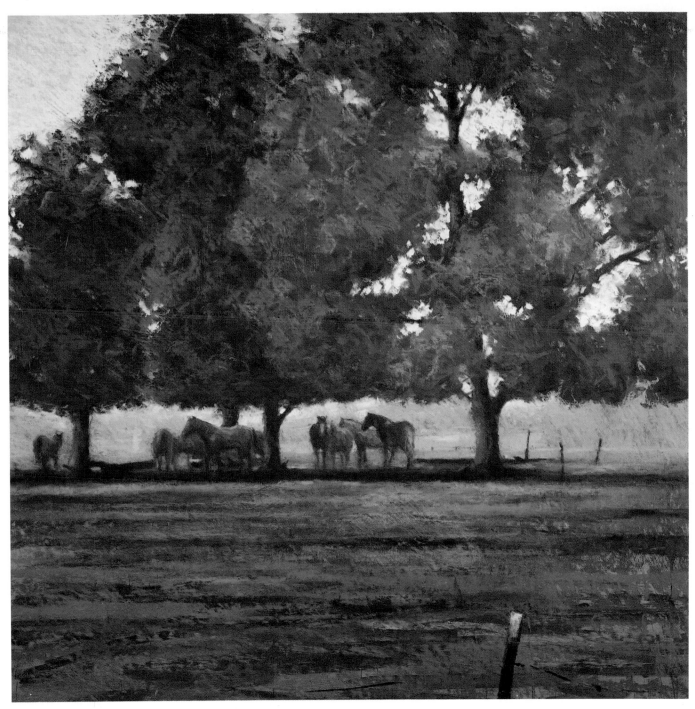

Under the Cottonwood
41" × 41", Doug Dawson, pastel
private collection

In Under the Cottonwood *everything from the horses and trees forward is foreground. The shift in color was exaggerated, making the background much cooler. The background space was divided into simple shapes with values that were very close to each other. This is at sharp variance from the foreground where the contrast between values is much greater.*

this happens is twofold. The light values get darker because, as explained earlier, it is as if you are looking at the distant objects through a pair of sunglasses. Therefore, the distant light objects appear a little darker than those in the foreground that are seen without the sunglasses effect. The dark objects, on the other hand, get lighter as they go back in space. The moisture and other particles in the air reflect a certain amount of light, causing a haze. The more air there is between you and the dark object, the more the object gets filled in with a light haze. In *Under the Cottonwood* the background was painted with little contrast in values, as if it were seen through just such a haze.

Overlap and Interlock

Another technique that will unify the painting and intensify its two-dimensional flatness is interlocking shapes in a jigsaw puzzle fashion. Then, to create depth, partially overlap these shapes to indicate to the viewer which is in front of the other. When one shape overlaps another, no other spatial device will countermand this powerful effect. Look at each shape in your painting and ask, "Can I shift another shape to overlap this one?" or "Can I add a new shape to overlap it?"

Deliberately set up some shapes parallel to the picture plane. This again will enhance the effect of depth. The beauty of these flat planes is that the

The Jungle Shop
15″ × 22″, Frank Webb, watercolor

The most expressive and direct spatial sensations in this painting result from overlapping the shapes of the foliage. Flat, simplified brushstrokes are interlocked with other strokes that are parallel to the picture plan. Almost every shape is overlapped.

Basic Landscape Techniques

picture space will remain open to a creative use of value and color. Rather than passively copying the model or motif, reorganize size relationships and shift positions of the elements in the picture to take advantage of overlapping. Build your own space just as you would build your own shapes.

Create Passage

While scanning the perimeter of any shape, look for areas where its value becomes very similar to the value of an adjacent shape or space. At such a juncture, minimize or eliminate the edge. This provides circulation; your eye is invited to pass through the connected areas, which might otherwise be iso-

lated with an edge. It also results in bigger, better overall shapes while weaving your painting together.

When two shapes are connected in this manner, one of the shapes will generally be closer in space than the other. But where the contour or edge is eliminated, the combined shapes will seem to lie in the same plane and at the same depth. These areas will also feel as though they are parallel to the picture plane. These two effects can add a dynamic spatial quality to your work. Check the work of Cézanne for this feature. Follow the contour of almost any shape in one of his paintings and see where he allows areas of value or color to fuse together. Art is a study of when to put together and when to take apart.

Wagon Whites
22" × 30", Frank Webb, watercolor

This painting has rivers of white that unite the background with the subject. Passages of this kind link pieces of a painting together. This painting won the Mary Pleissner Memorial award of the American Watercolor Society.

Values and Planes

Push Back Space With Arbitrary Values

If you deliberately darken a value that lies behind a light shape or object, the darker value will recede in space and push the lighter shape forward. This concept seems to work best when the background is light or white, and the color is somewhat understated. Reversing this ploy is almost equally effective.

Pushback values are usually gradated; after an edge is established, the value is discreetly faded away. Remember, too, that when a shape or area is pushed back it creates a space, whether its shape or value indicates that it is an object or just deep atmosphere. The term "arbitrary" describes these pushbacks because value and color in this procedure are not used to render things realistically but are created by the artist who wishes to use space as a creative idea.

Establish Planes

Planes, as they occur on the landscape or as facets which describe a cut diamond, are very useful for adding conviction to the concept and presentation of surfaces. Negative spaces can also be conceived as planes and as solid volumes rather than merely empty space.

It's good to have definite convictions as to whether a plane is parallel to the picture plane, or whether it turns obliquely away from the surface into depth. Try to visualize an axis for each plane, so that these movements can be felt and related over the entire picture.

Wilson's Mill, VI
22" ×30", Frank Webb, watercolor

Here pushback values are used. The subject is quite large on the paper. Using pushback values allows plenty of white to circulate through the picture. The subject is lost and found everywhere. The essence is a reciprocity of object and space. The distinction between them is minimized.

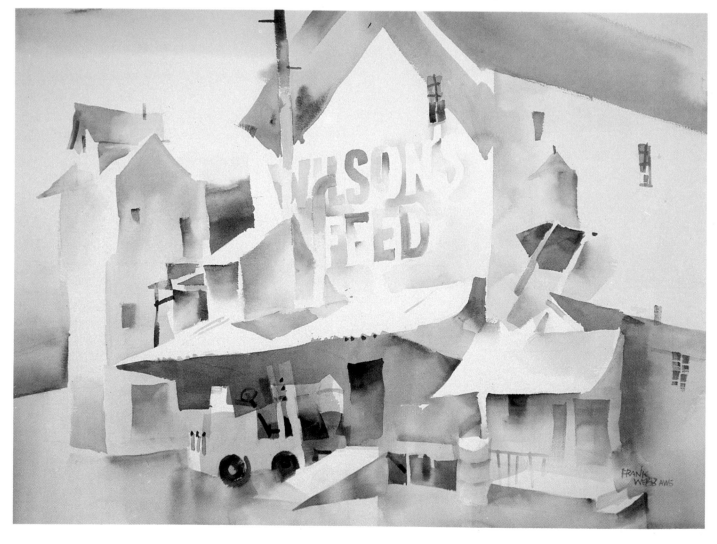

Basic Landscape Techniques

Geometrize

Flabby, irresolute or boring shapes of objects or spaces can be vitalized by conceiving them as spheres, cones, cubes or cylinders. Academic art schools historically taught this to clinch the "thereness" of mass or volume. Use this same concept to add conviction to negative shapes or spaces.

The most nebulous areas on any paintings are apt to be the skies. The sky in many paintings is often a smudge of blue stuffed into an area, with some clouds for good measure. A sky can be given the same conviction as a mountain if you conceive it as a geometrical shape (right).

Today, there are many ideas about creating pictorial space that were not known in the past, such as overlapping transparent planes, montage and imposed calligraphy. Photography has also conditioned us to accept the closeup view and the extremely high or low viewpoint. The most exciting discovery of modern art may be the use of color as a major means of creating space. The balancing of opposing forces of objects and space is felt by the artist as emotional tension. The person who beholds the work of art experiences these tensions not only through the eye but also in the musculature, the nervous system and the viscera. This means that the artist thinks with the whole body. As you try to carve out your own spaces, remember that your mental, physical and emotional self are fused into each painting. Every painting is a portrait of its author.

SKY AS A
CEILING

SKY AS A
HEMISPHERE

SKY AS A
CYCLORAMA

SKY AS A
HALF CYLINDER

SKY AS A
BACKDROP

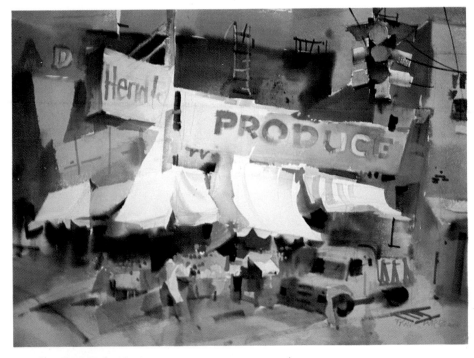

Pittsburgh's Market Square
22" × 30", Frank Webb, watercolor

This painting captures the spatial sensations of a city square. The space itself provides relief from the blocks stuffed with buildings and helps us get a fresh view. Notice the cube-like volumes under the awnings. Try to imagine the shapes of the volumes of space as they interact with your subject.

SKY AS A
BOX

Chapter Seven
PAINTING LIGHT
Illuminating Your Vision

It is light that makes it possible for us to see, yet in the most intense light objects and colors look washed out. Between these two extremes are a variety of lighting conditions that provide both inspiration and challenge for the artist.

There is consistency in light and shadow because light travels in straight lines. If the light shines from the left, highlights will be on the left and shadows will fall on the right. Light becomes more complex when it is diffused or reflected in another direction or when there is more than one light source. An artist can spend years trying to see and portray light accurately.

Color Temperature

Every source of light has a warm or cool cast to it. If you shine different kinds of light bulbs on a white sheet of paper, some will appear warm, almost yellow; others will be cool, bluish.

The shadows cast by a light will appear to be the opposite temperature from the light source. So if the brightly lit areas of your painting are all warm, then the shadowed areas should all be cool. Some artists simplify their painting by dividing the palette into warm colors on one side and cool colors on the other. This helps them maintain consistency in their painting and thus makes the light more believable.

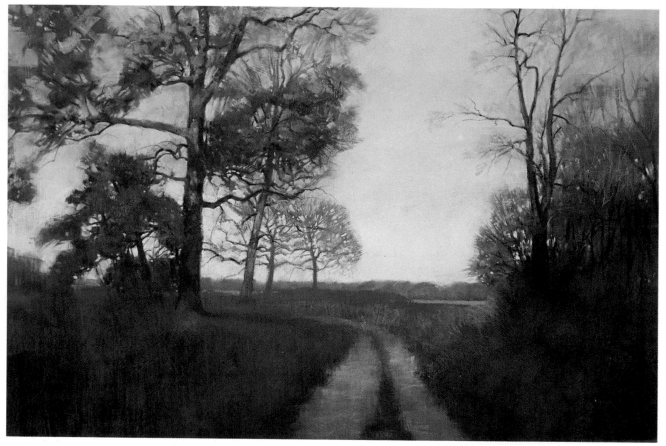

Morning Light
21"×31"
Robert Frank
pastel

What makes the sunlight apparent in these landscapes are the contrasting areas of shadow. It is the play between highlights and shadows that establishes light; one will not work without the other.

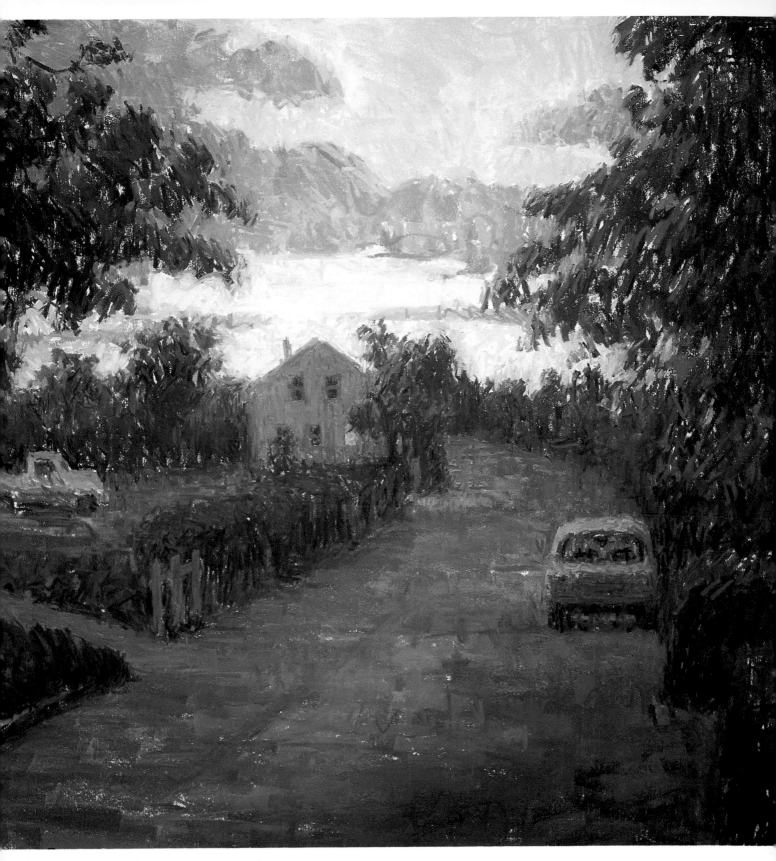

Sundown, 19″ × 19″, Simie Maryles, pastel

Understanding Light

The key to harnessing light and turning it into a workable pictorial device is in understanding the numerous ways it affects a subject. This is most easily done by simplifying the effects of sunlight at different times of day, weather conditions and seasons into four basic lighting conditions. Each condition has the potential to alter the mood of a subject. These are backlight, sidelight, toplight and frontlight. Within each of these is the potential for numerous variations. Sidelight, for example, could include three-quarter front or rear and range anywhere from low in the sky to high. All four conditions could also be applied to artificial light, candlelight, moonlight or any other source of light you may choose.

One good way to compare the features of the various approaches is to imagine a subject lit by each of the four different effects—for example, a single building set in a rural landscape. If staged under *backlight*, the sky in such a scene would be the brightest and warmest area of the composition. Most of the forms would appear in cooler, shadow passages and fall into a range between middle gray and black. Although a few areas of the landscape and building that are exposed to the sun would be painted lighter and warmer than the shadows, these too would appear deeper in tone than the sky. The ground plane would grow increasingly lighter in tone and warmer in color as it recedes back into the picture and becomes closer to the source of illumination. This backlit condition would reduce the subject to a series of dark shapes silhouetted against a light sky or imbue the scene with a blissful sense of tranquility.

Sidelighting is probably the most popular of all conditions to work under. Its sharp contrasts of light and dark reveal the form and texture of a subject and offer a wide range of descriptive shadows to help define the areas surrounding the object. Under this condition, the light-struck portions of a subject will be on whatever side the light is coming from. The sky and ground plane will also be affected. Each would deepen and cool in color as it gets farther away from the light.

Now imagine the same scene under *toplight*. The effect of the harsh glare from the noonday sun shrinks the long, descriptive shadows so characteristic of sidelight to a meager collection of stublike shapes. The lightest and warmest areas of the subject will be restricted to those forms that are at right angles to the light. There will also be a "hot spot" in the middle ground, because the sun is directly above. Not many artists choose this effect because of these very limitations.

Another form of toplight can be found on overcast days when the sun is obscured by clouds. In this case the sky becomes the outdoor equivalent of a ceiling filled with cool, soft fluorescent lights. Because of the filtering effect of the blue-gray clouds, the temperature of the light is reversed, with cool color bathing the lights and warm predominating the shadows. Shadows look softer under this condition and appear as dark, undefined halolike shapes gently radiating from beneath the various forms. One advantage overcast light has over bright sunlight is that the painter can work all day under an unchanging source of illumination.

The final effect is *frontlight*. Here, the light comes from behind the artist, making the sky appear darker. The foreground of the picture appears the lightest, with the tone and temperature deepening and cooling as the forms roll back into the distance. Another quality of frontlight is the predominance of light over shadow. This gives the artist an opportunity to use a warmer, higher-keyed palette and underplays the three-dimensional quality of a subject by eliminating most of the shadows so essential for solidifying a form. This "flattening out" effect can be useful in stressing the colorful shapes and patterns of a subject.

Backlight

Sidelight

Toplight

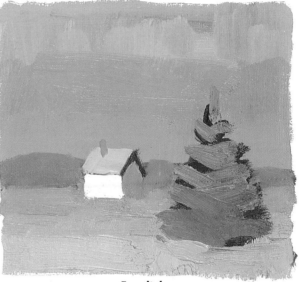

Frontlight

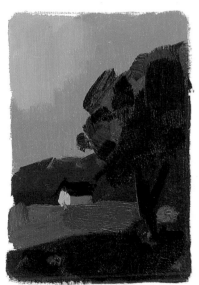

Moonlight

Artificial light

Candlelight

Exercise. The assignment for this exercise is to paint four sketches, incorporating each of the various conditions described. They can be easily duplicated indoors under artificial light and can be equally appropriate for still-life setups, figure compositions or interiors. The secret to capturing any of these effects is basing every tone and color on the position of the light and how it reveals the subject you're painting. You'll get more out of this lesson by choosing an identical theme for each of the sketches and more yet if you work from life rather than photographs.

A single source of illumination, by its very nature, can't help but unify a subject.

Unifying a painting with light can add a remarkable degree of believability to a composition. Thoroughly digesting these principles should provide you with a basic vocabulary of lighting effects that can be added to with each new encounter with light.

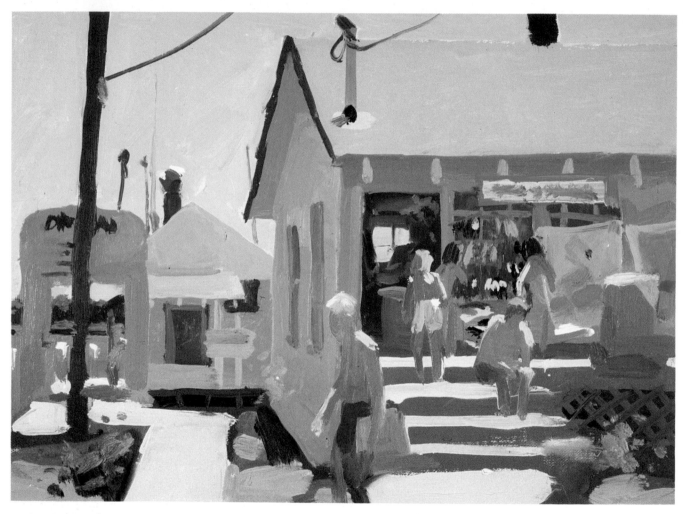

Ocracoke Island
12" × 16"
Charles Sovek
oil on canvas
private collection

This painting has a strong toplight, coming somewhat from the right.

Yosemite, Morning
6″ × 6″, Charles Sovek, oil on canvas
collection of the artist

This and the painting at the right show the changes that lighting can make on the same subject. Studies such as these are invaluable for discovering which condition best suits your needs.

Yosemite, Late Afternoon
6″ × 6″, Charles Sovek, oil on canvas
collection of the artist

Notice the dramatic light cresting the top of the mountain. It's up to the artist to investigate the many possibilities.

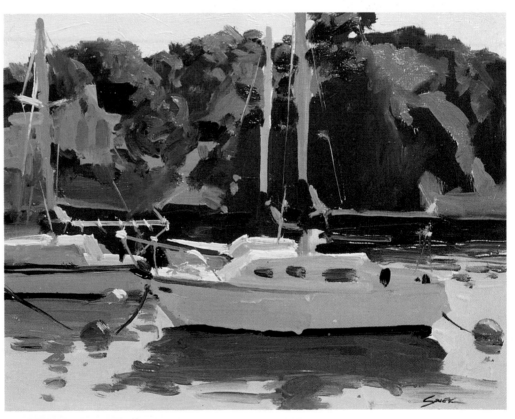

This is essentially a tonal painting and illustrates the point that choosing the right lighting (in this case backlighting) can go a long way toward the success of a picture.

Backlight on Five Mile River
12″ × 16″, Charles Sovek, oil on Masonite
collection of Jane Lincoln, Marstons Mills, Massachusetts

Filling Landscapes With Light

A landscape is composed of fields and trees, ponds and rivers, but nature is also composed of surfaces on which light falls. Light presents a challenge. The key to luminosity is small overlapping strokes of many colors.

The paintings shown here began with a careful drawing transferred to sanded, four-ply museum board. A full-color underpainting that details all the shapes, colors and values of the composition is done next. The sanded board will hold up to six layers of pastel.

To create the feeling of bright sunshine next to shadow, a bright tone (of a slightly darker value than needed) is stroked on over the entire sunlit area. The next layer is a lighter pigment covering the same area, but leaving a rim of the first color next to the shadow. The third layer, even lighter, again covers most of the sunlight but leaves a rim of the second color showing. The effect is of brighter and brighter light, precisely as we experience in nature. The result of this careful assessing of light and color is an image that looks solidly real, but glows with light.

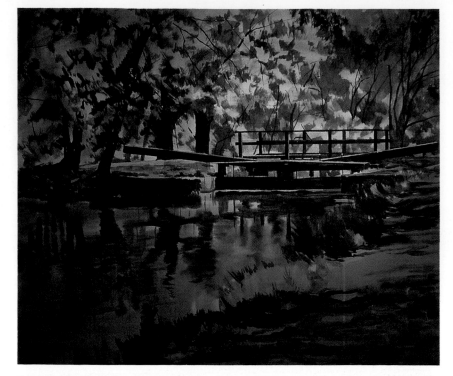

Step 1: The first step is painting the composition in acrylic, using slightly darker colors and values than the final pastel will be. The light pastels will have increased brightness because of this contrast.

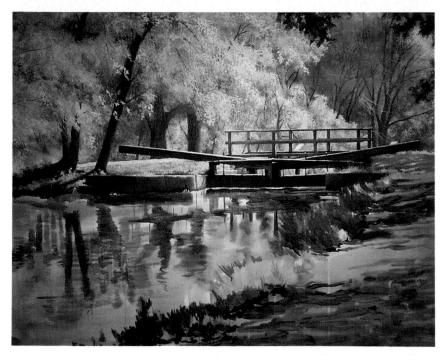

Step 2: The artist works from upper left to lower right to avoid smudging the pastel, completing each section totally before moving on to the next. Color temperature as well as value is used to distinguish light and shadow, such as the warm tones of yellow and green in the sunlit trees on the left and the cooler blues and greens in the shadowed trees on the right.

Basic Landscape Techniques

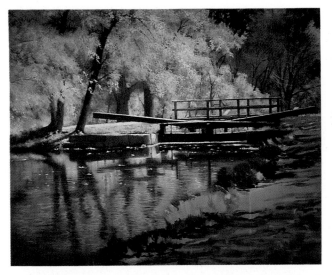

Step 3: In the water in the lower left, green is added for the cool reflections for the foliage above. Horizontal strokes on the water establish the flat plane of the pond's surface.

In this detail we can see the first layers of pastel applied to the path. Warm orange is used for the light areas and cool blue for the shadows. These are darker values that will be overlaid with lighter colors.

Later in the painting's development, the color of the path has changed. However, the underpainting still contributes to the value and color temperature. There are no edges between light and dark areas, which provides a smooth transition with strokes of middle values.

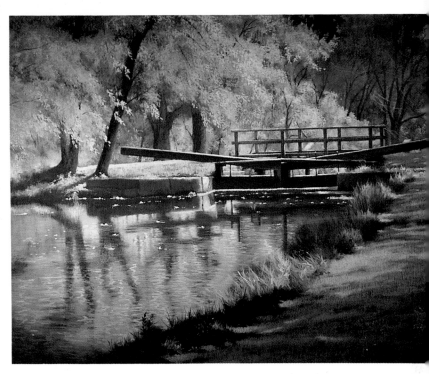

The Lock
32" × 40", Barbara Geldermann Hails, pastel

Step 4: The last section to be finished is the path on the right side. Notice the dappled sunshine on the path. Even on a cloudy day with intermittent sunshine, light invades shadow areas.

Color With a Punch

If you looked at the painting at lower right from a distance, you would see a solid, smooth-looking image, but up close the same painting breaks down into thousands of separate dabs of color, as was typical of the French Impressionists.

The surface here is rag illustration board, which allows acrylic underpainting, and a layer of ground pumice glued on with spray fixative. Rising is a board with a relatively smooth surface. Pastel glides across the smooth surface and the board also has the strength for extensive reworking.

This painting was done on a white surface. Note the dramatic skies in this country scene. The scene is broken down into a sparkling array of colored strokes.

This color study was done with acrylic and pastel. Both the study and the painting were done from a combination of photographs, drawings and observation.

Step 1: This loose sketch done in acrylic clarifies placement and composition. By keeping things loose and nonspecific you can see your idea without locking yourself in.

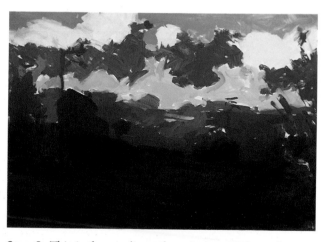

Step 2: This is the acrylic underpainting used to achieve a warm red glow. The acrylic maintains its integrity and doesn't blend with the pastel to muddy it.

Basic Landscape Techniques

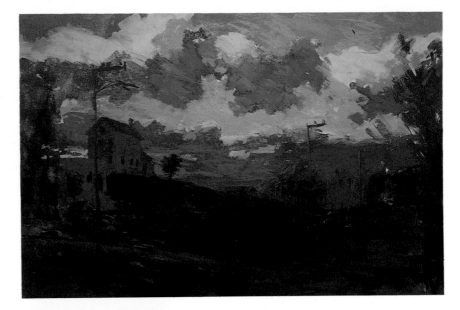

Step 3: At this point the painting is still broad and simple, but finished enough to be understandable. Application of pastels has begun, laying in cooler colors over the warm reds and pinks of the underpainting, mostly using the sides of the pastels. The red underpainting ties things together and adds contrast.

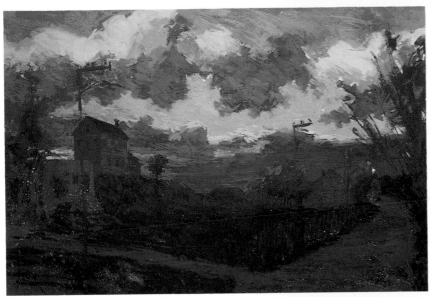

Step 4: As the painting progresses, areas are refined. The whole painting was sprayed to darken it. At this point you may refine an area, but find it has become over-refined; you can still wipe it out to simplify and start over.

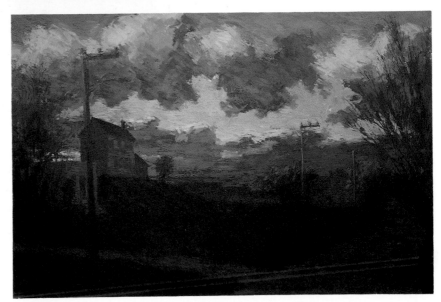

Autumn Skies: Sunset on Alden Street
24" ×36", Simie Maryles, pastel and acrylic

Step 5: There is more detailing, more fine branches in the trees, small strokes in the grass. Compare the original small study (top left) and this large piece. The one is more spontaneous and immediate and the other much larger and more refined.

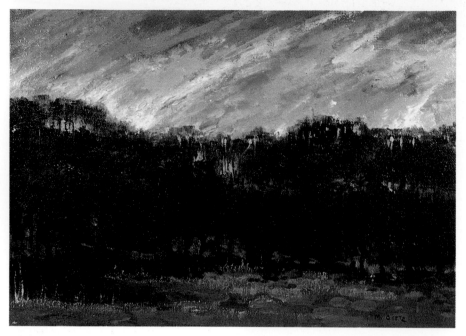

Bucks County Sunset
10" × 14", Mary Anna Goetz, oil
courtesy of Newman Galleries,
Philadelphia

In this painting, the dramatic sky,
streaked with gold bands, was the most
important element. The sky was painted
a la prima, in angular strokes. Attention
was focused on color variations rather
than refinement. To break up the mass
of dark trees, light pouring through
openings in the foliage was exaggerated.

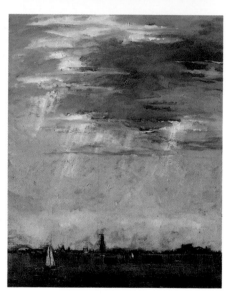

View From Brooklyn Anchorage—Before
30" × 24", Mary Anna Goetz, oil

Gusty winds combined with a sky full of
clouds make painting in windy weather
especially difficult. Mounds of clouds
constantly move across the sky, blocking
out the sun one minute, flooding the sky
with light again as they move on. This
was the situation of this painting. Work-
ing in these conditions, concentrate on
describing as much of the overall situa-
tion as possible.

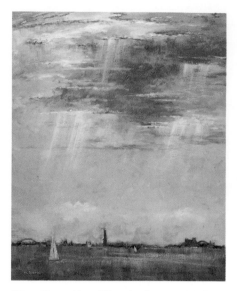

View From Brooklyn Anchorage—After
30" × 24", Mary Anna Goetz, oil
collection of Dr. and Mrs. Bruce Sorrin

In the studio, the clouds were modeled
and the brilliant colors that occurred
around their edges highlighted. The
shafts of light were emphasized more,
making them lighter, brighter and more
clearly defined. The shafts were dry-
brushed with a flat brush so they
wouldn't overwhelm the rest of the com-
position. Note the shafts of parallel light.

Step 1

Painting Clouds

Step 1: Begin by placing the clouds in the composition. Don't indicate the lightest, most luminous portions of the clouds until you have decided how to work these passages into the composition. Describe only the middle values in the beginning, as the very lightest and darkest portions of the clouds will tend to jump unless tastefully arranged.

Step 2: When you have decided on the placement of the clouds, refine them, lighten or mask the lightest lights, and lay in the darkest areas. Don't attempt to make an exact rendering of the cloud you're studying. Avoid too much detail. You don't want the clouds to look like objects.

Step 3: When it is time to apply color, begin by laying in the sky color. This helps define the shape of the clouds. It also enables you to relate the clouds to the color of the sky.

Step 4: When you begin work on the clouds, avoid piling on too much color. Otherwise the clouds will appear too solid. Study the color of the clouds. Pure white pigment won't produce convincing results. When refining the clouds, pay attention to their edges. Hard-edged clouds can create a cut-out look. Finally, don't be afraid to use your imagination to make the design of the clouds more interesting.

Step 2

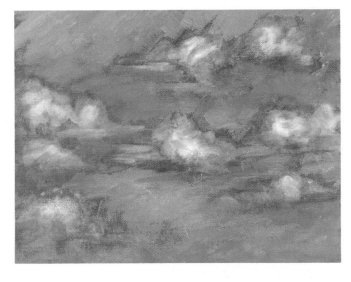

Step 3

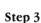

Step 4

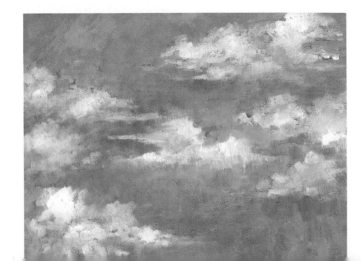

WATER

Capturing the Most Elusive Subject

There are three basic types of water—quiet water (almost motionless because it hasn't been disturbed), water with some motion (disturbed by some force acting against it, such as a boat moving through it) and rough water (greatly disturbed, as sea blown by a storm, crashing against the shore). Remember that the water will pick up reflections of anything else that may be on or near it.

It is no wonder that water fascinates us. Water is one of God's great kaleidoscopes, made up as it is of many small reflective shapes that are constantly moving. The very properties that make water fascinating, the fact that it is reflective and moving, also make it confusing. The best way to overcome this confusion is to study the predictable properties of water.

Autumn on the River
12" × 16", Charles Sovek, oil on canvas
collection of the artist

The tide causes myriad changes on the various inlets which flow into the ocean. Here, nearly black passages of mud skirted the thin stream of water. The dramatic effect is further heightened by the warm, light-struck grass and trees as they display their autumn color.

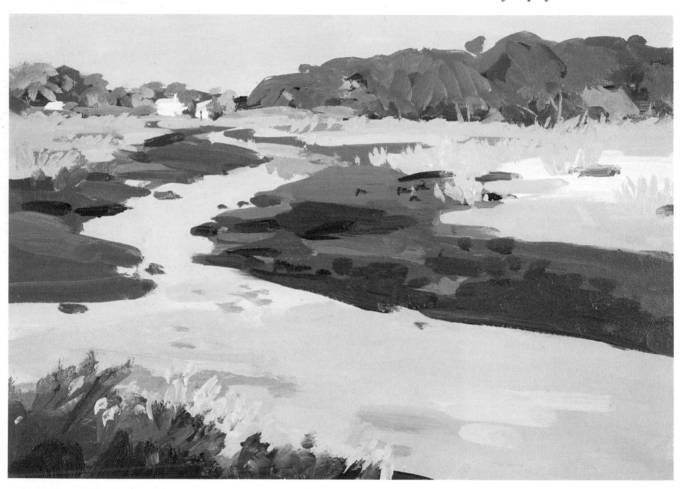

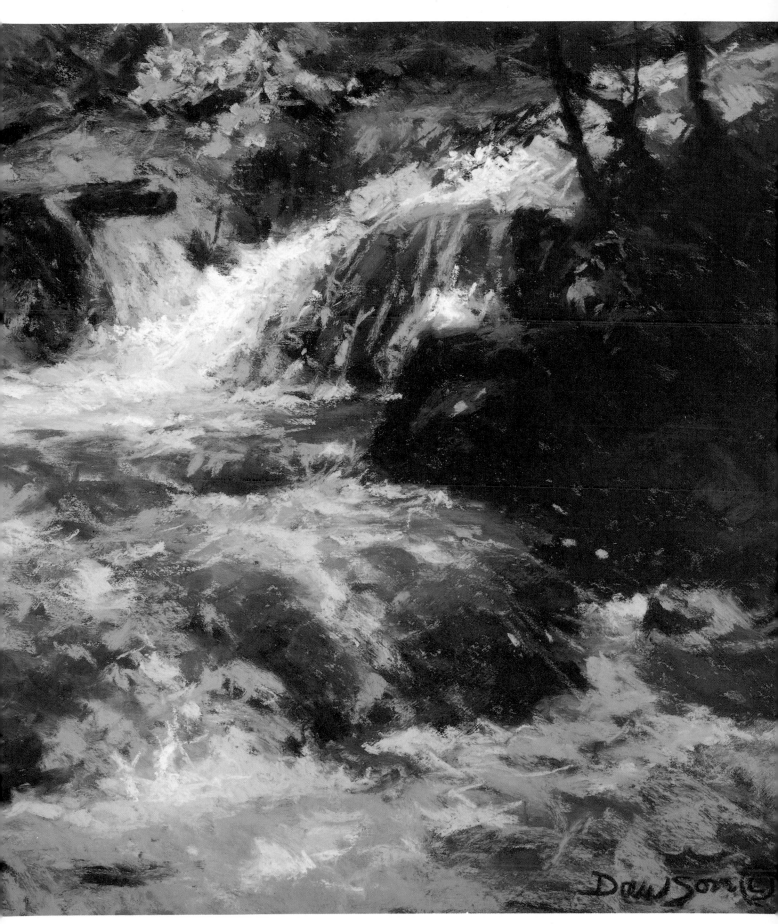

Cataract Below Berthoud, 20" × 24", Doug Dawson, pastel, collection of Mr. and Mrs. Lee

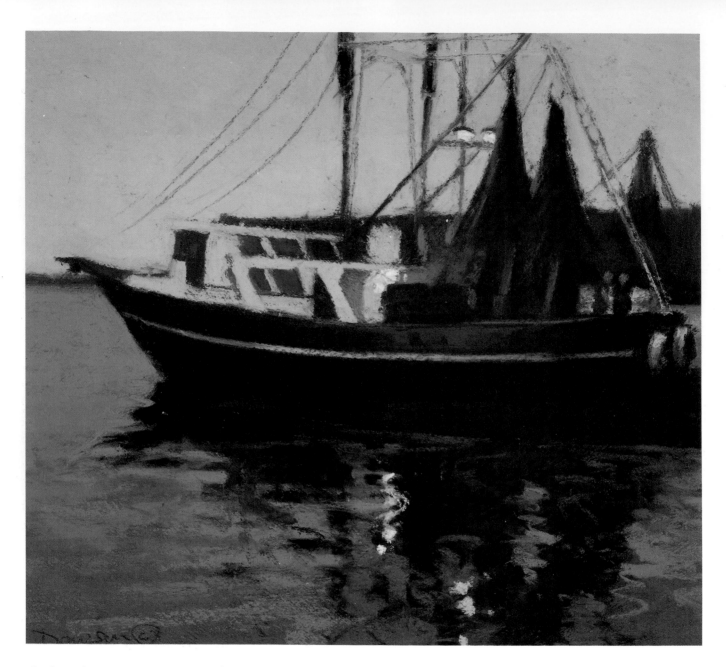

Checking the Nets
13" × 14½", Doug Dawson, pastel
collection of Susan Robins

The three "zones of reflection" are evident in this painting. However, be careful not to confuse shadows with reflections. Shadows always fall away from the light source, whereas reflections always come toward you.

The Three Zones of Reflection

There are three zones of reflection evident in water. Each has a characteristic pattern of reflection in its waves. All three patterns are evident in the painting *Checking the Nets*. Closest to the boat, both sides of the waves reflect the boat. The absence of sky reflections characterize this zone. Surrounding this space is a second zone. In this region the front side of the wave reflects the sky and the back side of the wave reflects the boat. This zone is typically broken up with a light and dark pattern. The last zone is made up of waves that reflect the sky on both sides, painted with slight color variations because the sky varies in color and each side of the wave reflects a different region of the sky. This third zone may be penetrated by the reflections of tall objects such as the masts of boats. All three of these zones may be present, just the second and third zones may be present, or just the third alone.

Water has color; therefore, it reflects like a toned mirror, causing light objects to appear darker than they actually are. In *Checking the Nets*, the reflection of the sky is several values

Basic Landscape Techniques

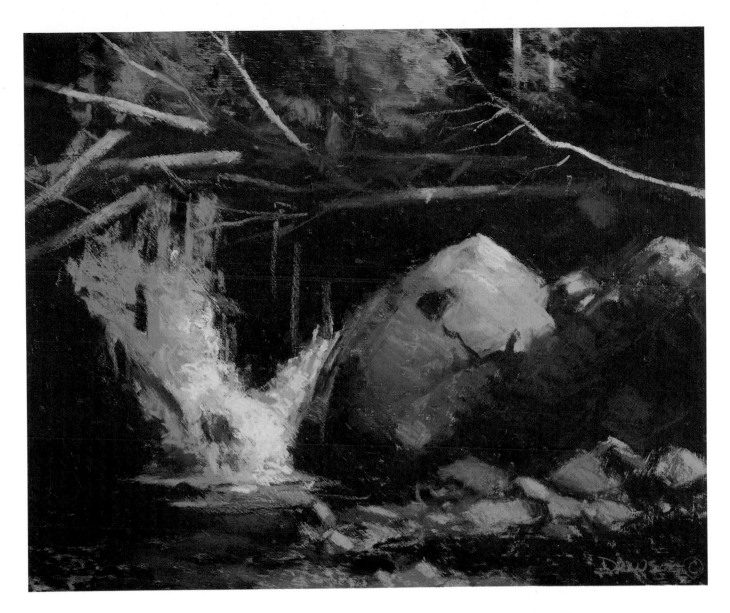

Below the Falls
19″ × 23″, Doug Dawson, pastel
collection of Michael R. Bieber, Ph.D.

Tumbling water behaves like waves reflecting the sky and other objects. The spray is the lightest value in the painting. Below the falls, the falling water caused a pattern of concentric, radiating waves on the pond.

darker than the sky. Similarly, the reflections of dark objects are a value or so lighter. Dark reflections get broken up with small spots of sky light reflecting off the water, and the eye interprets this mixture of light and dark as a slightly lighter value.

Don't confuse shadows with reflections. Shadows always fall away from the source of light, but reflections come toward you.

Painting Wave Patterns
Water is constantly moving, yet certain patterns repeat themselves. The pattern of waves rolling in on a beach repeat, but not with every wave. Rocks and other obstacles cause patterns as water rushes over them or rolls against them. When you are painting water, look for the big repetitive patterns, the big shapes. Don't get caught up in the detail of one little wave or reflection.

Study photographs of the different types of water problems. Study the patterns of waves and the patterns of reflection. Look for the ways in which water repeats itself.

The Three Layers of Water

When you look at water you may see as many as three overlapping layers. The top layer includes everything floating on the surface, such as foam, boats, lily pads and so on. The middle layer is the surface of the water itself. If nothing is floating on the water this may be the only visible layer. The bottom layer is anything under the surface of the water, such as fish or the bottom of the lake. In most situations, the bottom layer is not visible and you don't have to worry about it.

Visualize the middle layer as if it were a broken mirror, made up of many small, flat reflective surfaces. The arrangement of these reflective surfaces is determined by the shape of the waves and the wave patterns. A simple wave is made up of two reflective shapes, the front of the wave and the back of the wave. If the wave is rolling in toward you, the front part behaves like a mirror tilted toward you. It will reflect the sky above or to your back. The back of the wave behaves like a

mirror tilted away from you and reflects the sky or objects in back of it.

While the bottom layer is usually not visible, when it is seen, it should be blocked in first. After the bottom layer is blocked in, paint the light reflections of the middle layer. In this way, the middle-layer shapes will overlap the bottom-layer shapes, mimicking the way the light reflections on the water overlap the objects underneath.

Painting Planes in Water

Water must be divided into planes. The foreground plane in water is usually that space where the shapes of waves are clearly visible. The background plane is that space where the waves are too small to paint individually, where they must be represented as pattern or

textures on the water. The middle ground, if there is one, is the transition between these two. If a painting includes land and water, the planes of the water should be aligned with the planes of the land. The painting *Below Berthoud* has a simple foreground and background. The line that separates the land into foreground and background cuts across the water at the top of the falls and divides the water into foreground and background as well. The water above the line is painted in simple linear shapes that imitate the pattern of groups of waves above the falls. Below the line the individual wave shapes are painted tumbling over the rocks.

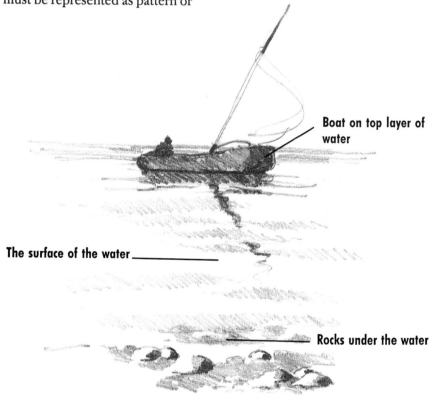

Boat on top layer of water

The surface of the water——————

Rocks under the water

In order to simplify this complex subject matter and paint water more easily, it is helpful to think of water as having three planes.

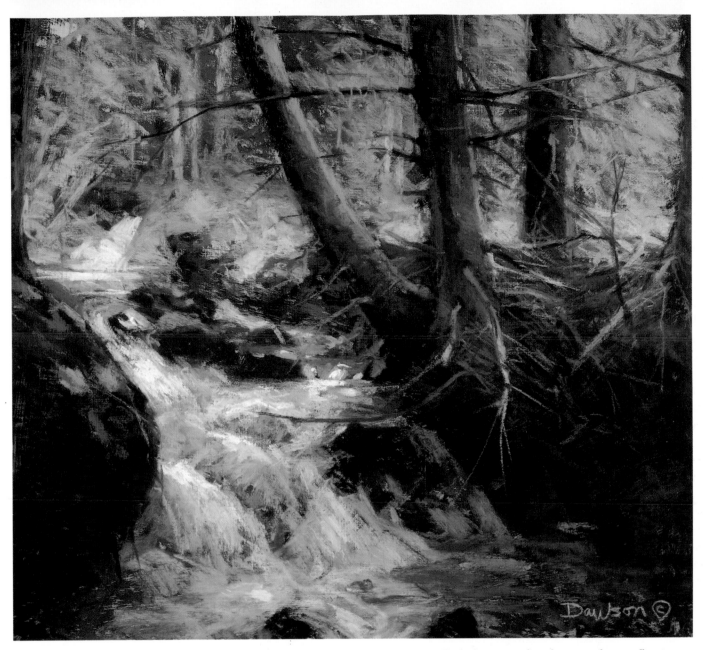

Below Berthoud
24" × 26½", Doug Dawson, pastel
private collection

Foam on the surface of water is usually lighter in value than anything reflecting on the middle layer, short of the sun. This is because foam is made up of little bubbles, each of which reflects points of light. Don't confuse it with the light sky reflections of the middle layer. It can't reflect objects the way the middle layer can. Because it rides above the water like whipped cream, it has a light side and a shadow side, and shadows may be visible on it. Foam is typically present where waves break on a beach or where water tumbles over falls.

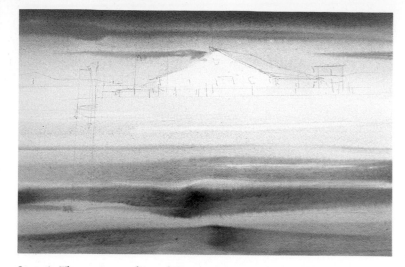

Step 1: The entire surface of the paper was moistened except for the building. A gradated wash that started darker and cooler at the top and became lighter and warmer at the horizon was laid in. While that area was still wet, darker value of the same colors were brushed in, dry on wet, to indicate the cloud formations. Next the water was painted in a mirror image of the sky using the same sky and cloud colors. While the water area was still wet, slightly oblique streaks of darker value were brushed in, mostly dry on wet, to indicate disturbed water. Before the area dried, some lighter streaks were lifted with a thirsty brush.

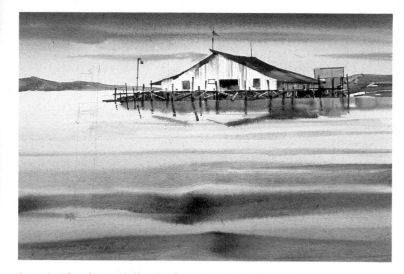

Step 2: The distant hills, the fishing shack and docks were painted. The water area below the docks was rewet and then the reflections were painted, some a bit sharper than in the quiet water scene.

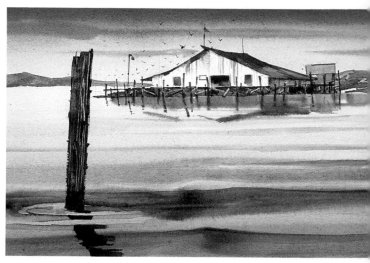

Step 3: Finally, the old post in the water was added along with its reflections. Notice how the rippling water gives the reflections very distinctive S-curves. You can also see how much sharper the reflections close to you are than those seen in the distance. A darker value was added to the top of some of the waves in the foreground and that was washed down with clear water.

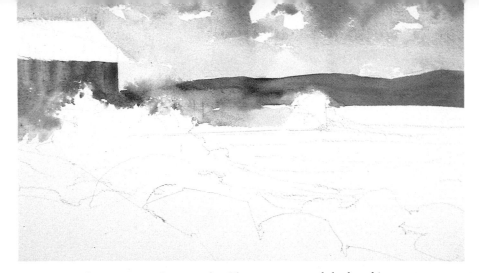

Breaking Waves

This is the most difficult of all types of water to paint and takes much thought and practice. To paint the form of breaking waves, wet the area around the foam with clean water, spraying some of the edges with a spray bottle to get a different texture from that of the water. Spraying leaves little pinholes of light that suggest foam and give some rougher texture to contrast the edges softened by the water.

Remember to have the foam flying in the same direction as the wave and the wind to help add action to the painting. If the wave and the wind actions are going in opposite directions (which can happen), the foam will go in the same direction as the wind. The shadows are painted in the direction that the foam is flying, and some edges are softened while other edges are left a little rough.

Step 1: The sky was painted wet on dry. The paper around the breaking water was wet with a brush and clear water. A spray bottle was used to spray droplets of water into some of these edges to get different textures for the flying spray. The distant hills were painted next, followed by the fishing shack.

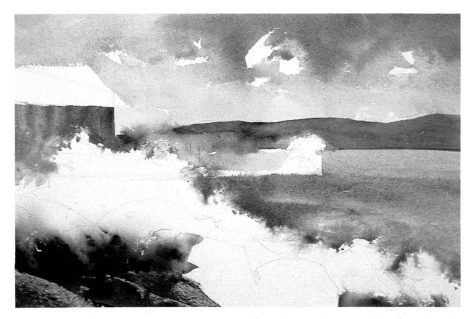

Step 2: The edges of the flying sea spray and beneath the wave were softened in the same manner as in the previous step. The colors of the rocks were painted into the soft and textured clear water.

Step 3: The rocks outside the breaking water were painted. While this area was still wet, texture was scraped into the rocks with a razor blade. White of the flying spray was also scraped out. The shadows in the breaking water are a grayed blue.

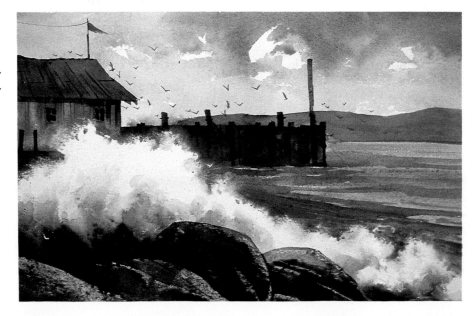

Rocks and Rushing Water

When painting rapidly flowing water, put three or four separate puddles of color on your palette. Pick up these colors on the brush, one at a time, letting them mix on the paper and not on the palette. To give rocks texture, spray and lift: Apply very heavy color to the paper, let the colors set for a minute or so, and then spray droplets of water back into it. When the time is right, lay a tissue over the area, press or otherwise mark through, and then lift.

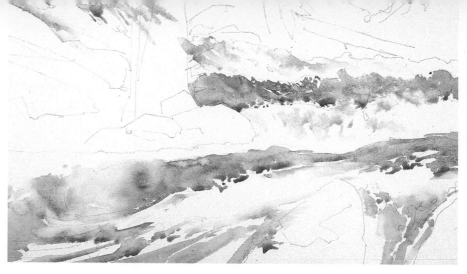

Step 1: Paint the water first, wet on dry. Make puddles of color on your palette and let them mix on the paper. Keep the brushstrokes moving in the same direction as the churn and flow of the water.

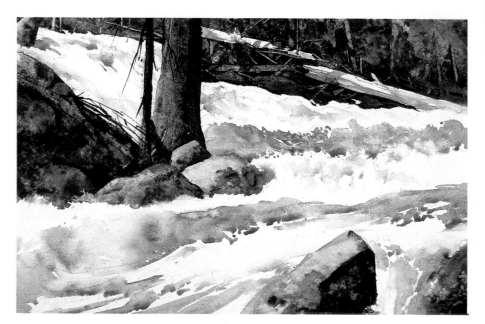

Step 2: The colors of the rocks were painted on with fairly heavy pigment, then sprayed with droplets of water and lightly blotted with a tissue. The background was painted next, with texturing that was the same as the rocks.

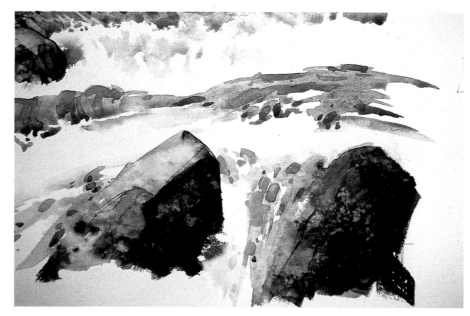

Step 3: In this close-up of the rocks, you can clearly see the marvelous coloring and texture that are made possible by painting the colors on somewhat heavily, spraying droplets of water from a spray bottle, and lightly blotting with a tissue.

Basic Landscape Techniques

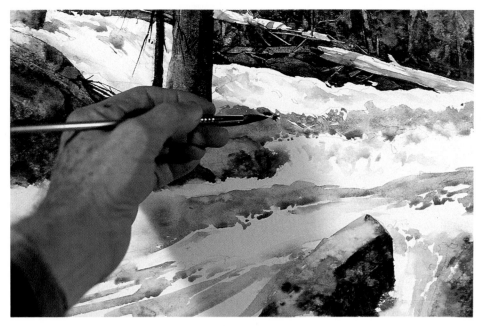

Here more detail is added in the water and dapples of shadow that play across the rushing water. The values in the shadow areas are deepened.

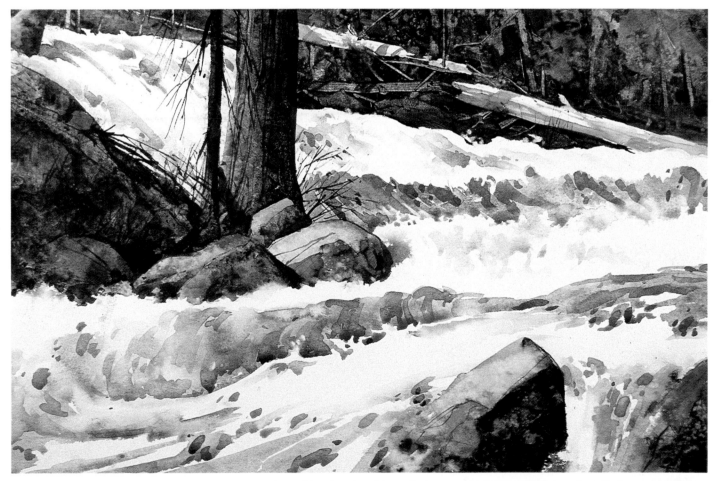

Down Cascade Canyon
11" × 14", Al Stine, watercolor

A subject like this should not be overworked. The water was handled very simply. Some weeds and twigs were added to finish the painting.

Still Water

The most important thing to remember when painting still water is to keep it simple and transparent. Striking effects can be created by working color and other variations into a composition that includes a body of water. However, it's important to keep these variations subtle, and not to clutter up the composition with lots of ripples or to pile on thick layers of paint.

Reflections are often an important consideration. If they're too defined, they draw attention away from the focal point; therefore, muting or softening the reflection.

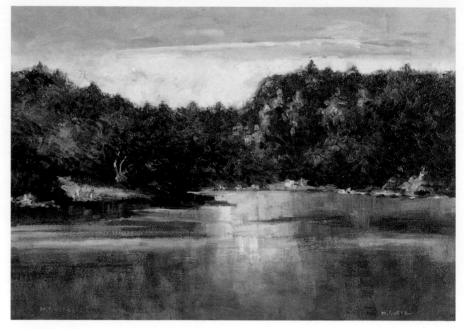

Mohonk Lake
18" × 24", Mary Anna Goetz, oil, collection of Dauphins Depositors Bank and Trust

A gust of wind created silvery ripples in the lake and eliminated much of the crisp reflection from the trees and cliffs. The reflected colors are still there, however, slightly muted to avoid conflict with the center of interest—the column of light in the water reflecting the sun.

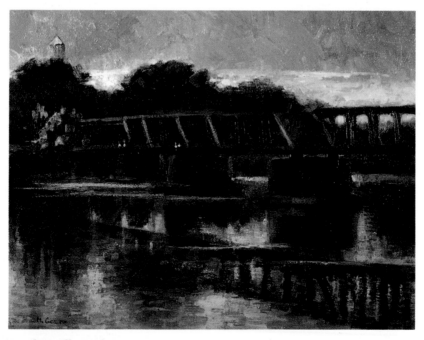

Lambertville Bridge
16" × 20", Mary Anna Goetz, oil, courtesy of Newman Gallery, Philadelphia

The reflections don't make a mirror image of the bridge and foliage in the background. Since water is translucent, don't build up a lot of paint or texture unless you decide to feature the water. Painting the sky in a thinner technique draws the eye toward the water and lends more focus to the bridge.

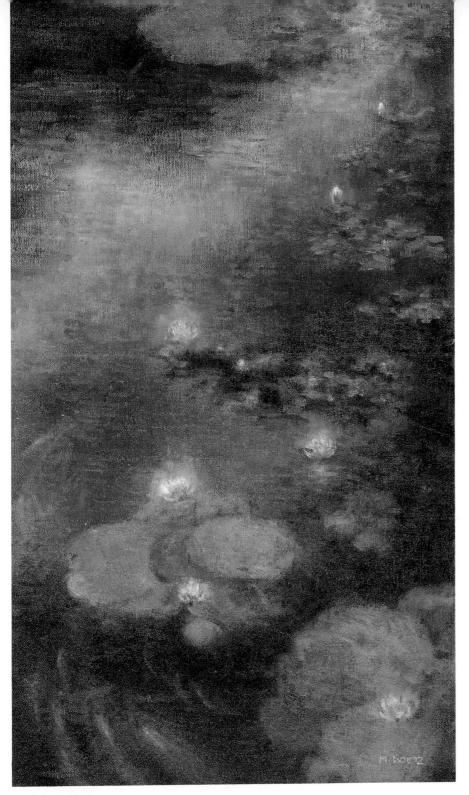

Detail from A Secret Place.
The fish were laid in, then dry-brushed with the color of the water. This enhanced the illusion that they're underwater. Their edges were softened so they wouldn't look like cut-outs.

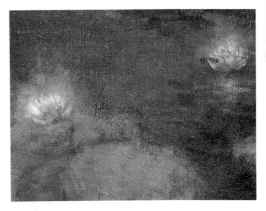

Detail from A Secret Place.
The shimmering, bright lilies looked almost like candles floating in the warm-colored water. The lilies were painted using white pigment in the lightest areas, and then the edges were dry-brushed to soften them and create a glowing effect.

A Secret Place
40″ × 20″, Mary Anna Goetz, oil
collection of Richard Fuchs

The vertical format and the goldfish trailing through the water add an oriental touch that make this composition more striking. The goldfish also helps lead the viewer into the less intricate upper portion of the composition.

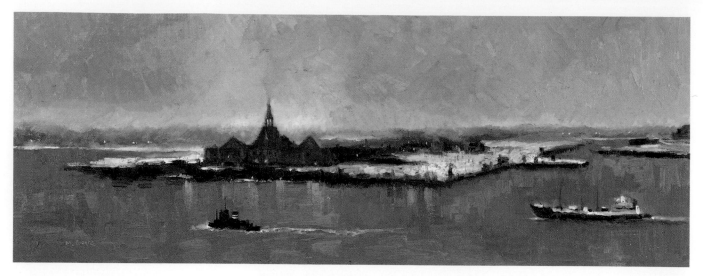

Hoboken Ferry Slip
10" × 20", Mary Anna Goetz, oil
collection of the Union League Club,
New York

Though the building itself is interesting, the subject wouldn't have been as paintable on a clear day without the snow. On this winter day, however, the pearl gray sky and water and the contrasting snow-covered patterns made this a much more interesting subject. Using a long, horizontal format also helped, because all the elements in the composition were pretty simple. Finally, adding a few boats in the water and some lights along the shoreline helped enliven the composition, without destroying the simple concept that made it appealing in the first place.

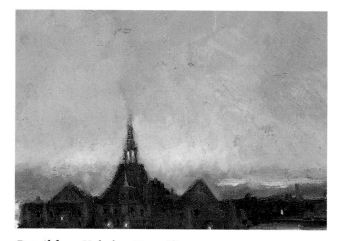

Detail from Hoboken Ferry Slip.
Remember that gray is a color, too. Mixing black and white will not result in a beautiful pearl gray sky. Notice the many subtle changes occurring in the color. Portions can look orange-gray (try adding cadmium orange) or pink gray (rose madder or permanent rose). For this sky, yellow ochre was worked into the wet paint.

Detail from Hoboken Ferry Slip.
The water was laid in first and then the boat was added. It was sketched in the grisaille, then refined with the tip of the brush. The wake was suggested using a little pure white paint.

View From Battery Park
28½" × 39½", Mary Anna Goetz, oil
collection of Mr. and Mrs. David Winterman

A thin wash was used to cover the canvas and record every-thing in one outing. In the studio, more depth was added to the horizon by modeling the shoreline and refining details. En-hancing light notes in the composition (for example, the wake from the boat in the foreground) and creating a more luminous quality to the water made that area less flat and dull. The cloud streaks were designed with a thin wash, and texture was built up later with a pure pigment.

Snow reflects light and breaks the land up into powerful light and dark patterns. Light snow often leaves open patches of grass and rocks. Heavy snow covers everything. One of the best times to go out is when the snow has started to melt off. The melting process exposes the ground and creates interesting interlocking patches of snow and earth. And when the snow is melting, the weather is warmer and more comfortable to work in.

When the snow is heavy, avoid flat places and look for streams or rough terrain. Heavy snow on rough terrain has interesting shadow patterns, because the snow echoes the irregular contours of the ground underneath. The sides of rocks and fallen tree trunks may remain exposed, breaking up the snow with small, irregular dark shapes. And over an open stream the snow melts away, leaving water and ground visible.

Fall River
24" × 26", Doug Dawson, pastel
corporate collection

Buggy Stop
12¼" × 17¼", Frank Nofer, watercolor
courtesy of Newman Galleries

The snow and sky comprise about 60 percent of this picture. They play an important role by setting off the shapes and textures of the subject.

Avoid White

Avoid white when painting snow. Try to create the illusion of white without using white. In *Fall River* (page 113), a light raw umber was used in combination with a light blue for the lighter values. White accents the lightest shapes in the distant foreground. In most snow paintings, don't use white at all.

The Color of Light on Snow

Because snow is white, it reflects the color of the sun in the lights and the color of the sky in the shadows. At sunrise or sunset, the light reflected by the snow is pink or orange. Shortly after sunrise it turns yellow-orange. Later in the morning it becomes yellow and, eventually, yellow-green about noon. The process reverses itself as the day goes on from noon to sunset.

Complicating the observation that snow reflects the color of the sun in the lights and the color of the sky in the shadows is the fact that these reflected colors become cooler as they go back in space. This color shift must be exaggerated to make it work. Lights shift from yellow to orange to red as they are successively filtered out by the air.

Nederland Country
20" × 22", Doug Dawson, pastel
collection of Therese L. Faget

Nederland Country *was done at about ten in the morning. The sun was yellow, so the light in the foreground is yellow. The light on the background snow is cooler painted yellow-orange. If the foreground light had been orange, as it might be right after sunrise, it would have appeared red-orange in the background.*

Basic Landscape Techniques

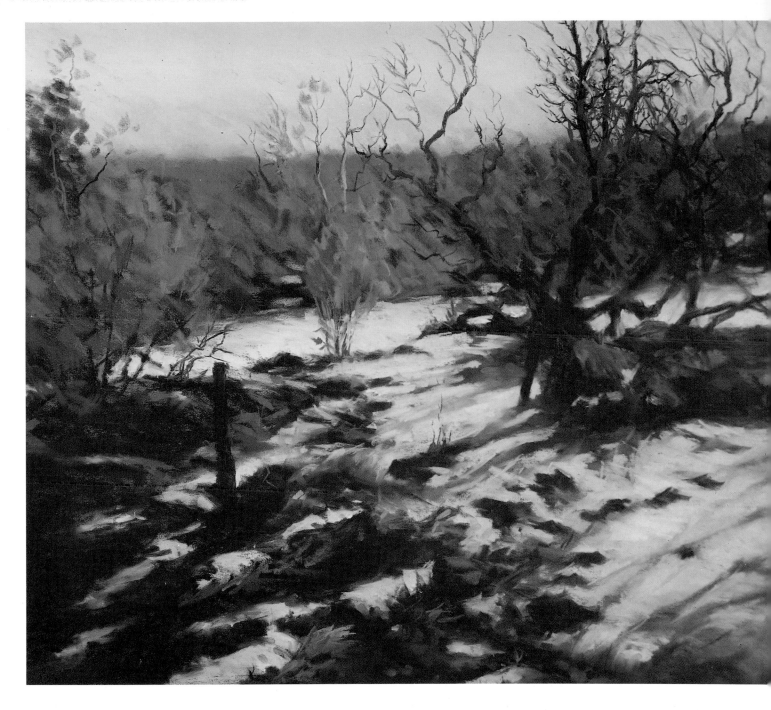

The Color of Shadow on Snow

The principle that colors get cooler as space recedes holds true for shadows as well as for lights. An important difference is that shadows reflect the light of the sky, usually blue-green, blue-violet or blue; therefore, they are already cool. Shadow colors shift from blue-green to blue-violet to blue as space recedes because first the yellow is filtered out by the air, then the oranges, then the reds. If shadows are blue in the foreground, lacking any green or violet properties, they remain blue in the background. Remember, however, that the sky changes color from overhead to horizon and from one region to another. If these changes are dramatic, you can expect similarly dramatic changes to occur in the shadows on the snow. The snow will reflect the different regions of the sky depending upon its angle relative to the sky.

Hoarfrost in Coal Creek
27½" × 29½", Doug Dawson, pastel
corporate collection

The sky was green-blue near the horizon and blue overhead. Both of these colors appear in the foreground shadows. In the background the green blue is eliminated and just blue is used.

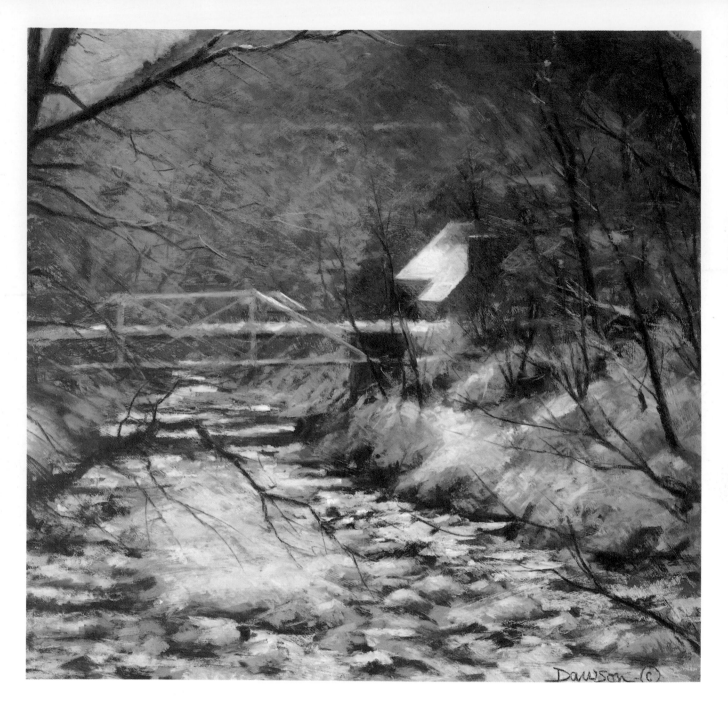

Upper Bear Creek
33" × 33", Doug Dawson, pastel
collection of Joe Branney

Darks were blocked in first and then lights worked around them to avoid getting a lot of muddy color from working darks over lights.

Painting Snow With Pastels

Block in the Darks First

Avoid setting up a painting in such a way that it forces you to paint dark over light. *Working dark over light is the recipe for muddy color.* The greater the value differences, the greater the likelihood of mud. Since snow is so light, the risk of muddy color is great.

In *Upper Bear Creek* the snow and water are broken up into many small shapes by the many rocks and small ar-

eas of open ground. This brokenness, the strong contrast between these small shapes, is an important part of the painting. If the snow were blocked in first, some of the snow shapes would have been in the wrong position and dark shapes would have been worked over them, resulting in muddy color. The darks were blocked in first and then lights were worked around them. A rough impression of the background, mountain and trees as well as the many small, dark rock shapes, the underside

Basic Landscape Techniques

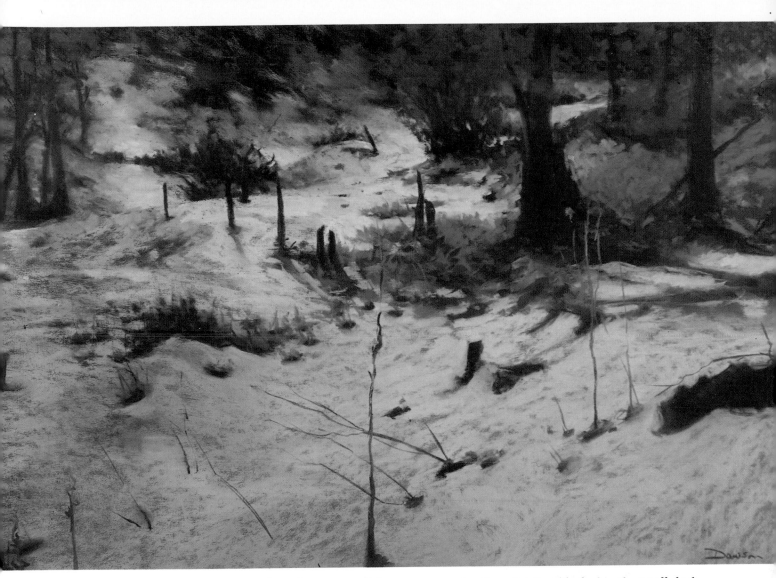

Firewood Gulch
24" × 36", Doug Dawson, pastel
collection of Gertrude Spratlen

To show the contour of the uneven terrain, the artist first blocked in the small dark shapes of exposed earth. He then painted the light values of snow in and around them, slightly overlapping the dark, to show that the snow is on top of the ground. Last, he repainted the edges of the dark vegetation to overlap the snow.

of the bridge, the tree branches, and open areas of ground were then blocked in.

When the darks were arranged, shadow values of the snow were blocked in, then finally the lights.

Getting the Edges Right

Edges are a special problem in a snow painting. It is often necessary to over-lap a background snow shape with the upper edge of a darker vegetation shape in front. This mimics the overlapping of edges in nature and gives the illusion that one shape is in front of the other. But multiple strokes of dark color over a light color stir up the color and cause mud. Anticipate the overlap and reduce it as much as possible.

After overlapping the necessary edges, the last step in painting *Firewood Gulch* was to paint in the thin shapes of individual plants in the foreground. These were painted directly over the snow using single heavy strokes of pastel so there was less danger of stirring up the mud.

INDEX

Improve your skills, learn a new technique, with these additional books from North Light

Watercolor

Basic Watercolor Techniques, edited by Greg Albert & Rachel Wolf $14.95 (paper)

Buildings in Watercolor, by Richard S. Taylor $24.95 (paper)

The Complete Watercolor Book, by Wendon Blake $29.95

Fill Your Watercolors with Light and Color, by Roland Roycraft $28.95

How To Make Watercolor Work for You, by Frank Nofer $27.95

Jan Kunz Watercolor Techniques Workbook 1: Painting the Still Life, by Jan Kunz $12.95 (paper)

Jan Kunz Watercolor Techniques Workbook 2: Painting Children's Portraits, by Jan Kunz $12.95 (paper)

The New Spirit of Watercolor, by Mike Ward $21.95 (paper)

Painting Nature's Details in Watercolor, by Cathy Johnson $22.95 (paper)

Painting Watercolor Portraits That Glow, by Jan Kunz $27.95

Splash I, edited by Greg Albert & Rachel Wolf $29.95

Starting with Watercolor, by Rowland Hilder $12.50

Tony Couch Watercolor Techniques, by Tony Couch $14.95 (paper)

The Watercolor Fix-It Book, by Tony van Hasselt and Judi Wagner $27.95

Watercolor Impressionists, edited by Ron Ranson $45.00

The Watercolorist's Complete Guide to Color, by Tom Hill $27.95

Watercolor Painter's Solution Book, by Angela Gair $19.95 (paper)

Watercolor Painter's Pocket Palette, edited by Moira Clinch $15.95

Watercolor: Painting Smart, by Al Stine $27.95

Watercolor Tricks & Techniques, by Cathy Johnson $21.95 (paper)

Watercolor Workbook: Zoltan Szabo Paints Landscapes, by Zoltan Szabo $13.95 (paper)

Watercolor Workbook: Zoltan Szabo Paints Nature, by Zoltan Szabo $13.95 (paper)

Watercolor Workbook, by Bud Biggs & Lois Marshall $22.95 (paper)

Watercolor: You Can Do It!, by Tony Couch $29.95

Webb on Watercolor, by Frank Webb $29.95

The Wilcox Guide to the Best Watercolor Paints, by Michael Wilcox $24.95 (paper)

Mixed Media

The Artist's Complete Health & Safety Guide, by Monona Rossol $16.95 (paper)

The Artist's Guide to Using Color, by Wendon Blake $27.95

Basic Drawing Techniques, edited by Greg Albert & Rachel Wolf $14.95 (paper)

Being an Artist, by Lew Lehrman $29.95

Blue and Yellow Don't Make Green, by Michael Wilcox $24.95

Bodyworks: A Visual Guide to Drawing the Figure, by Marbury Hill Brown $10.95

Business & Legal Forms for Fine Artists, by Tad Crawford $4.95 (paper)

Capturing Light & Color with Pastel, by Doug Dawson $27.95

Colored Pencil Drawing Techniques, by Iain Hutton-Jamieson $24.95

The Complete Acrylic Painting Book, by Wendon Blake $29.95

The Complete Book of Silk Painting, by Diane Tuckman & Jan Janas $24.95

The Complete Colored Pencil Book, by Bernard Poulin $27.95

The Complete Guide to Screenprinting, by Brad Faine $24.95

Tony Couch's Keys to Successful Painting, by Tony Couch $27.95

The Creative Artist, by Nita Leland $12.50

Creative Painting with Pastel, by Carole Katchen $27.95

Drawing & Painting Animals, by Cecile Curtis $26.95

Drawing: You Can Do It, by Greg Albert $24.95

Exploring Color, by Nita Leland $24.95 (paper)

Fine Artist's Guide to Showing & Selling Your Work, by Sally Price Davis $17.95 (paper)

Getting Started in Drawing, by Wendon Blake $24.95

The Half Hour Painter, by Alwyn Crawshaw $19.95 (paper)

Handtinting Photographs, by Martin and Colbeck $29.95

How to Paint Living Portraits, by Roberta Carter Clark $28.95

How to Succeed As An Artist In Your Hometown, by Stewart P. Biehl $24.95 (paper)

Keys to Drawing, by Bert Dodson $21.95 (paper)

The North Light Illustrated Book of Painting Techniques, by Elizabeth Tate $29.95

Oil Painting: Develop Your Natural Ability, by Charles Sovek $29.95

Oil Painting: A Direct Approach, by Joyce Pike $22.95 (paper)

Oil Painting Step by Step, by Ted Smuskiewicz $29.95

Painting Floral Still Lifes, by Joyce Pike $19.95 (paper)

Painting Flowers with Joyce Pike, by Joyce Pike $27.95

Painting Landscapes in Oils, by Mary Anna Goetz $27.95

Painting More Than the Eye Can See, by Robert Wade $29.95

Painting Seascapes in Sharp Focus, by Lin Seslar $10.50 (paper)

Painting the Beauty of Flowers with Oils, by Pat Moran $27.95

Painting the Effects of Weather, by Patricia Seligman $27.95

Painting Towns & Cities, by Michael B. Edwards $24.95

Pastel Painter's Pocket Palette, by Rosalind Cuthbert $16.95

Pastel Painting Techniques, by Guy Roddon $19.95 (paper)

The Pencil, by Paul Calle $19.95 (paper)

Perspective Without Pain, by Phil Metzger $19.95 (paper)

Photographing Your Artwork, by Russell Hart $18.95 (paper)

Putting People in Your Paintings, by J. Everett Draper $19.95 (paper)

Realistic Figure Drawing, by Joseph Sheppard $19.95 (paper)

Tonal Values: How to See Them, How to Paint Them, by Angela Gair $19.95 (paper)

To order directly from the publisher, include $3.00 postage and handling for one book, $1.00 for each additional book. Allow 30 days for delivery.

North Light Books
1507 Dana Avenue, Cincinnati, Ohio 45207
Credit card orders call TOLL-FREE
1-800-289-0963
Stock is limited on some titles; prices subject to change without notice.